THE *GREAT HURRICANES* OF *NORTH CAROLINA*

THE *GREAT HURRICANES* OF *NORTH CAROLINA*

JOHN HAIRR

The History PRESS

Published by The History Press
Charleston, SC 29403
www.historypress.net

Copyright © 2008 by John Hairr
All rights reserved
All photos courtesy of the author unless otherwise noted.

First published 2008

Manufactured in the United States

ISBN 978.1.59629.391.5

Library of Congress Cataloging-in-Publication Data
Hairr, John.
The great hurricanes of North Carolina / John Hairr.
p. cm.
Includes bibliographical references.
ISBN 978-1-59629-391-5
1. Hurricanes--North Carolina. 2. Hurricanes--North Carolina--History. I.
Title.
QC945.H25 2008
551.55'209756--dc22
2008003139

Notice: The information in this book is true and complete to the best of our knowledge. It is offered without guarantee on the part of the author or The History Press. The author and The History Press disclaim all liability in connection with the use of this book.

All rights reserved. No part of this book may be reproduced or transmitted in any form whatsoever without prior written permission from the publisher except in the case of brief quotations embodied in critical articles and reviews.

Contents

Introduction	7
The Independence Hurricane of 1775	21
The Twin Hurricanes of 1806	31
The Great North Carolina Hurricane of 1815	41
The Great North Carolina Hurricane of 1827	49
Charlie Tiegen's Hurricane of 1856	55
The Great Beaufort Hurricane of 1879	67
The San Ciriaco Hurricane of 1899	81
The Great Atlantic Hurricane of 1944	105
Hurricane Hazel	125
Hurricanes of the Late Twentieth Century	139
Appendix: The Saffir-Simpson Hurricane Scale	149
Bibliography	153

INTRODUCTION

Hurricanes have long been a fact of life in the Carolinas. With its lengthy, exposed coastline jutting into the Atlantic Ocean and reaching out nearly to the Gulf Stream, there is little wonder that these tempests have visited the land since before there was a North or South Carolina. Hurricanes have literally shaped the land along our coast, and in a sense, the people as well.

This book discusses the most fearsome and violent hurricanes that have made landfall along the North Carolina coast. All hurricanes have the potential to be destructive, but throughout the years several hurricanes that have visited the state were notable for a variety of factors, including high winds, massive floods or the large number of fatalities they left in their wakes. In a land that is frequently visited by tropical storms, each generation seems to have a benchmark storm against which all others are measured. This book takes a look at all of these storms, and investigates the state's most powerful and memorable hurricanes.

INTRODUCTION

Storm debris from Hurricane Hazel litters the mainland near
Lockwood's Folly Inlet in Brunswick County. *Photo courtesy Wilmington
District, U.S. Army Corps of Engineers.*

A hurricane is a tropical cyclone with maximum sustained winds of seventy-four miles per hour or greater. Tropical cyclones are systems of large, rotating thunderstorms that form over warm, tropical water. Due to the effects of the earth's rotation, these storms rotate in a counterclockwise fashion in the Northern Hemisphere, and rotate clockwise in the Southern Hemisphere. They are found in all areas of the tropical regions of the world. These tropical cyclones are called hurricanes in the North Atlantic once they exceed the seventy-four-mile-per-hour threshold.

The word "hurricane" has its origins in the names given to the storm gods by various tribes of Native Americans inhabiting the islands and mainland surrounding the Caribbean. It is certain that the Native Americans who

INTRODUCTION

The *Calypso* was battered by the high winds and heavy seas it encountered in a fierce hurricane that struck the North Carolina coast in August of 1837. Captain Gilbert Wilkinson, master of the *Calypso*, managed to bring his severely damaged vessel into port inside the Cape Fear River. He afterward observed: "We were kindly received by the good people at Smithville and Wilmington who complained bitterly of the late storm, for many of their houses were unroofed, and trees blown down."

inhabited the land we now call North Carolina experienced the high winds and heavy rains of these storms. Unfortunately, they left no written accounts of their experiences.

When the Europeans first attempted to found settlements along the coast, they quickly learned about these storms. Sir Francis Drake, who had traveled the seas of the globe in quest of glory and plunderage, nearly lost his fleet on the Outer Banks during an encounter with a hurricane in June

INTRODUCTION

of 1586. His ships were anchored just off the banks while he checked on the progress of Sir Walter Raleigh's colonists on Roanoke Island. The hurricane lasted three days, scattering Drake's fleet and nearly destroying many of his ships.

As time passed and settlers learned more about their new homeland, they experienced these storms on such a regular basis that they became accustomed to them. Eventually they began calling them equinoctial storms, as the storms normally hit in the weeks around the period of the fall equinox, which in the Northern Hemisphere occurs in late September.

Thanks to four hundred years of observations and advances in technology, we now know that hurricanes can strike at any time between June and November. The peak of hurricane season in the Carolinas is in the month of September. Several early storms have been chronicled in June, the earliest striking on June 2, 1825. Only a handful of late-season storms have hit in November and December. The latest recorded storm moved out of the Caribbean and struck the North Carolina coast on December 2, 1925.

In 1858, Dr. David Ramsey, an eminent authority on the early history of South Carolina, wrote the following observations about these storms in the early days of European settlement in the Carolinas:

> *The autumnal equinox seldom passes in the vicinity of the torrid zone without some conflict of the elements more or less dangerous. In the 138 years which have*

taken place since the settlement of Carolina, several minor storms have passed over without exciting any permanent public attention. But four having done extensive mischief, are particularly remembered, and have been called hurricanes, an appellation usually given to those convulsive storms in the West India Islands in which the fields of sugar canes are destroyed, and the canes torn up and hurried away in confusion.

Ramsey wrote that the four hurricanes that did "extensive mischief" along the Carolina coast were the ones occurring in 1700, 1728, 1752 and 1804. All were particularly bad storms, but the one that occurred on September 15, 1752, was perhaps the most severe. It was the first of two powerful hurricanes to strike the Carolina coast in as many weeks. Charles Town was inundated, ships were wrecked and many people lost their lives. Two weeks later, another violent hurricane struck South Carolina, though it was not as destructive in Charles Town as the first storm had been. This killer storm made landfall somewhere between Winyah Bay and Cape Fear before heading north and ravaging the North Carolina coast. This was the storm that destroyed the town of Johnston, the former county seat of Onslow County.

There were other notable hurricanes that struck back in the days when North Carolina was still a colony of Great Britain. One occurred in September 1761 when waters breached "the Haulover," which was a sandbank separating the Atlantic from

INTRODUCTION

the Cape Fear River. The resulting channel was found to be eighteen feet deep, but it filled in somewhat before stabilizing at about nine feet deep. The channel, dubbed New Inlet, remained open for over a century until it was closed by a rock dam constructed by the United States Army Corps of Engineers.

On September 7, 1769, a powerful hurricane that landed somewhere between Cape Fear and Cape Lookout flattened the Brunswick County courthouse and nearly flattened the town of New Bern. At Brunswick Town, Governor William Tryon wrote:

> *In short, my Lord, the inhabitants never knew such a storm; every herbage in the gardens had their leaves cut off. This hurricane is attributed to the effects of a blazing planet or star that was seen both from Newbern and here rising in the east for several nights between the 26th and 31st of August, its stream very long & stretched upwards towards the So West.*

We know quite a bit more today about the origin and nature of hurricanes than Governor Tryon did back in 1769, or at least we think we do. Tropical cyclones frequently begin as an organized area of thunderstorm activity that holds together for twenty-four hours. As a tropical disturbance gets better organized, rotation becomes more pronounced, and once an area of closed circulation forms, it becomes a tropical depression. As the tropical depression intensifies and the sustained winds

Introduction

increase to thirty-nine miles per hour, the depression becomes a tropical storm. The system becomes a full-blown hurricane as winds exceed seventy-four miles per hour.

As the winds at the center of the storm increase to hurricane force, the ring of intense storms begins to form around the center of circulation. This wall of thunderstorms is called the "eyewall," and it is the portion of a hurricane that contains the strongest winds. At the center of a tropical cyclone, the area at the very center of the vortex is known as the eye, and it becomes more pronounced as the thunderstorms intensify. The eye of a storm is normally an area of light winds, clear to partly cloudy skies and no rain. The size of a hurricane's eye varies from storm to storm, ranging in size from just a few miles across to over fifty miles across. In addition, the eye of any given storm will expand and contract as the hurricane interacts with other forces.

Conditions inside the eye of a hurricane can be quite bizarre, with low pressure affecting the ears. Reuben Frost, weather bureau chief for the National Weather Service at Wilmington, North Carolina, interviewed many people who experienced Hurricane Hazel in 1954. He collected some interesting observations about conditions as the eye of the storm passed over southeastern North Carolina, and he wrote the following valuable observations about the eye of the storm at Calabash:

> *Local people on the North Carolina coast use the Old English pronunciation of "kam" for calm. People at Calabash stated the sudden "kamming" of the wind and*

Introduction

> *low pressure affected their ears, and there was a spooky, eerie feeling or sensation. One local lady said the "kam" spell gave her the "creeps." After a few minutes she saw a very black and ugly bank of clouds approaching from the southwest. There was an awful roaring noise that scared her more than ever. In just a matter of seconds the "kam" was over and the awful wind began blowing from the southwest.*

Ignorance of the characteristics of hurricane structure has often led to injury or death for those who mistake the calm weather inside the eye of a hurricane for the end of the storm. Emerging from cover, these individuals are caught in an exposed position when the hurricane-force winds resume. Often, in the eye of the storm the winds will shift and blow in the opposite direction, catching those in its path off guard.

Along the Outer Banks, the counterclockwise rotation of the winds around the eye of a strong hurricane often causes strong onshore winds that back water up into Pamlico and Albemarle Sounds. With the passage of the eye, powerful hurricane-force winds drive this water back across the sounds and out toward the ocean. The sandy islands act as a barrier to the passage of this water, which frequently cuts new channels and inlets through the banks as it is driven back out to sea. On several occasions, the storm surge and this wind-driven water emptying out of the sounds have combined to inundate portions of the Outer Banks, changing the shape of the island chain when the water recedes.

Under the right conditions, this water backed up into the sounds can produce dramatic floods with fatal consequences. During the San Ciriaco Hurricane in August of 1899, several fishermen from Down East communities in Carteret were caught unexpectedly in the storm while fishing in the shallow waters of Pamlico Sound, near the mouth of the Neuse River. They rode out the initial onset of the hurricane but made the fatal error of thinking the calm weather inside the eye of the hurricane was the end of the storm. As they proceeded to Cedar Island, they were overtaken by a wall of water blowing out of the Neuse River that swamped some of their vessels and killed fourteen men.

Some of the most ferocious hurricanes form off the Cape Verde Islands in the eastern portion of the Atlantic Ocean, hence the term "Cape Verde Storm." These storms frequently start as a band of thunderstorms that move off the African coast and develop into tropical cyclones off the Cape Verde Islands. The cyclones intensify as they head west and cross the warm open waters of the Atlantic between the Lesser Antilles and Africa. By the time they make it to the Caribbean, these storms often develop into major hurricanes.

Several factors decide whether one of these Cape Verde storms will reach the mainland of North America. Some storms continue to ride the trade winds all the way into Central America, while others begin to drift to the northwest, passing into the Gulf of Mexico and plaguing the Gulf Coast states. Other storms follow a more northerly track and again

Introduction

curve to the north in the vicinity of the Greater Antilles and Bahamas. These particular storms often follow a path that brings them into or near the coast of North Carolina.

Based on weather observations and information on hurricanes gathered throughout the years, meteorologists are able to determine the likelihood of a hurricane making landfall near a given locale along the coast. In North Carolina, the place with the highest probability of being near the center of a hurricane or tropical storm is Cape Hatteras. But such predictions are based on historic accounts of hurricanes and help very little in predicting the specific path of an individual tropical cyclone.

Today, meteorologists rely on a whole arsenal of tools to help keep track of hurricanes. Satellites in orbit around the planet have been beaming back photos of tropical cyclones from space since 1954. Radar, which was designed to keep track of an enemy's whereabouts during wartime, has evolved into a multicolored mosaic that is now watched by millions to follow the movements of a storm in real time. In addition, at any given moment, Hurricane Hunter aircraft are flying into the heart of these storms, taking measurements and sending back information that helps scientists increase their knowledge of the mechanics of how a hurricane works.

Researchers rely on a sophisticated scale to measure damage and storm intensity of a hurricane. Known as the Saffir-Simpson Scale (see Appendix), it rates hurricanes based on a variety of factors, including wind speed and

INTRODUCTION

barometric pressure. On the Saffir-Simpson Scale, hurricanes are classified ranging from the weakest, Category One, to the strongest, Category Five.

Prior to the creation of the Saffir-Simpson Scale, meteorologists classified hurricanes utilizing a system that was based, for the most part, on the strength of a hurricane's wind speed and barometric pressure. If a hurricane had winds between 74 and 100 miles per hour and a minimum central pressure between 29.03 and 29.40 inches, it was a minimal hurricane. A hurricane whose winds were between 101 and 135 miles per hour with a minimum central pressure of between 28.01 and 29.00 inches was considered to be a major hurricane. Powerful hurricanes with wind speeds greater than 135 miles per hour and a minimum central pressure of 28.00 inches or lower were designated as great or extreme hurricanes. Sometimes a hurricane with wind and pressure that did not meet the respective criteria could be upgraded to the next level if there were extenuating circumstances such as widespread destruction and loss of life.

Regarding wind speed, it is important to realize that the maximum sustained winds that are reported for hurricanes today are measured differently than they were in the past. Prior to the 1870s, there were no wind speeds measured along our coast during hurricanes, as there were no official weather stations set up to take the necessary readings. In the mid-1870s, the United States Army Signal Service established stations all along the North Carolina coast and

Introduction

was able to observe some remarkable storms that struck the state in the latter half of the nineteenth century.

When reporting the maximum winds for a storm, the Signal Service calculated the average wind speed observed over either a five-minute interval or a ten-minute interval. One instruction manual published in the 1870s even suggested averaging the speed over a twenty-minute interval, but the five-minute method seems to have been the one most widely employed. This method of averaging out the winds over several minutes of time was subsequently followed by U.S. Weather Service observers into the middle of the twentieth century.

Today, in the United States, the maximum sustained winds are calculated using an average taken over a one-minute interval. Other countries around the world frequently use a ten-minute average when calculating maximum sustained winds. Meteorologists have discovered that winds measured under the one-minute system are generally nearly 13 percent stronger than would be reported if the ten-minute system were employed. This poses some interesting challenges when comparing modern storms with storms of the past and suggests that maximum sustained winds in hurricanes of the late nineteenth and early twentieth centuries were generally underreported. If measured using our modern system, these storms were actually stronger than originally reported.

Not to be confused with maximum sustained winds are gusts, which only last for a few seconds. Scientists have discovered that the speed of a three-second wind gust is 30

INTRODUCTION

percent higher than the maximum sustained winds calculated using the one-minute method.

Oftentimes, the most devastating part of a hurricane is the storm surge, which is an abnormal rise in the level of the sea experienced during a hurricane or tropical cyclone. Normally, the stronger the hurricane, the greater the storm surge will be. Several factors play a key role in the height of the surge, including wind speed, shape of the shoreline and atmospheric pressure. This rise in the level of the sea during a storm is in addition to the normal action of the astronomical tide, which is caused by the moon.

When hurricanes make landfall, they often unleash torrential rainstorms over inland areas that result in catastrophic floods. Few realize that, in the United States, floods are currently the leading cause of hurricane-related deaths, not strong winds or the devastating storm surge. These floods frequently occur in areas well inland from where the hurricane makes landfall, especially mountainous areas such as the Appalachian Mountains in the southeastern United States. Prime examples of this were the devastating floods that struck western North Carolina in July of 1916 due to rainfall from a hurricane that made landfall near Charleston, South Carolina. At Altapass, 22.22 inches of rain fell during a twenty-four-hour period on July 15–16, 1916, setting a record not just for this state, but for the entire country.

Another historic hurricane-related flood was the Great Freshet of 1795. In that eventful year, two hurricanes struck

INTRODUCTION

North Carolina within ten days of each other, sending the state's rivers on a rampage and causing floods of record-setting proportions. The first storm made landfall near Wilmington on August 2 and passed across the eastern portion of the state. Most notable casualties from this storm were the eighteen vessels of the Spanish fleet that came ashore near Cape Hatteras.

But it was the year's second hurricane that was responsible for the massive flooding that affected all portions of the state. We do not know exactly where this hurricane made landfall on August 12, but by August 13 it had spread across North Carolina and into southern Virginia. A note found in the records of the Moravians gives an idea of the intensity of the rains:

> *The storm came in great gusts from the east, and one could hear the roaring from a distance, some of the fruit trees were broken off at the roots, and the heavy rain was driven against the houses with such heavy force that it penetrated the walls, even when built of stone...The flood twenty-one and a half inches higher that the one last month, and that was higher than anything seen since Salem was founded.*

It is important that we study the history of these storms and their impact on North Carolina. Information gathered can help keep current and future storms in their proper perspective. Hurricanes have occurred in times past, and they will continue to be a part of the North Carolina experience long after we have gone the way of Sir Francis Drake and Governor Tryon.

THE INDEPENDENCE
HURRICANE OF 1775

The Independence Hurricane of 1775 was a ferocious, deadly storm that ravaged the colonies just as the chaos of the Revolutionary War was descending upon North America. The killer storm maintains its place in the annals of North Carolina hurricanes because of its destructiveness and lethality. This potent hurricane remains the most deadly storm to ever strike North Carolina, claiming at least 170 lives as it passed through the eastern portion of the province.

Ironically, the Independence Hurricane is often confused with an even more lethal storm that plagued the colonies during the month of September. There is much confusion about the exact nature of the event that caused so many casualties in the Canadian Maritimes. Some have even theorized that the episode in Canada was caused by a deadly tsunami and was not the work of a tropical cyclone. Regardless of the cause, the death toll in Canada has been estimated to be as high as four thousand people.

Independence Hurricane
North Carolina's Most Lethal Hurricane
September 2nd, 1775

"We have intelligence likewise of a brig that was drove ashore at Curratuck, just beyond the Capes, which stove to pieces, where two passengers and every hand on board, except the captain and an apprentice, perished."

Fifteen people killed near Lake Mattamuskeet.

A correspondent from New Bern writes, "We had a violent hurricane the 2d instant, which has done a vast deal of damage here..."

The storm claims 150 lives at Ocracoke Inlet, the most important passage through the Outer Banks during the Colonial Era.

Storm makes landfall somewhere along the southern portion of the Outer Banks on September 2nd, 1775.

The Independence Hurricane of 1775 was the most lethal hurricane to ever strike the North Carolina coast. Over 170 people died as a result of this powerful storm, which struck somewhere in the vicinity of Ocracoke on the morning of September 2, 1775.

The Independence Hurricane of 1775

There has also been much confusion about the exact day of the month the event in Canada occurred. Governor Robert Duff reported that the incident took place in Newfoundland on September 12, 1775, and resulted in the loss of three hundred lives in his province. Hurricane historian David Ludlum noted that a hurricane struck the Nova Scotia coast on September 9, 1775. From this, we can establish the dates on which the deadly storm plagued the provinces from Nova Scotia to Newfoundland. This was not the same hurricane that struck the North Carolina coast on September 2 and passed back out to sea off the New England coast by September 4, 1775.

Now that we have established that the Independence Hurricane of September 2, 1775, and the Great Newfoundland Storm of September 12, 1775, were two separate events, it is possible to discuss the first storm and examine its impact on North Carolina.

Even though it was not as lethal as the subsequent storm, the Independence Hurricane was still a potent storm. The high winds and heavy rains devastated much of the land along its path. Hundreds of lives were lost, ships were driven ashore or lost at sea and much devastation was left in the wake of this powerful tempest as it tracked north through the colonies from North Carolina to Massachusetts.

Because firsthand accounts of the storm in North Carolina are so rare, it is difficult to ascertain the storm's exact track. Governor Josiah Martin was aboard a British warship, the *Cruizer*, anchored near the mouth of the Cape Fear River, not

far from Fort Johnston. In his dispatches to London, he made no mention of a hurricane or gale blowing at his location. Nor is there any record of a storm in the log of the ship upon which the governor was seeking refuge during these early days of the Revolutionary War.

From this lack of reports of a powerful storm in the Wilmington area, one can determine that the storm must have passed to the east and come ashore farther up the coast toward Cape Lookout or Cape Hatteras. Exactly how far east, though, is difficult to determine, but thanks to an account of the storm that appeared in the pages of the *South Carolina & American General Gazette*, a newspaper published in Charles Town, South Carolina, one can deduce that the storm must have made landfall closer to Cape Hatteras than to Cape Fear.

Several days after the storm had passed up the coast, the newspaper published this account of the storm and its aftermath, penned by an observer whose name was unfortunately not recorded. Thanks to this article, we know that by 6:00 a.m. on September 2, 1775, "violent hurricane winds out of the n.e." were battering the observer at Ocracoke Inlet. Whether he was safely ashore at Portsmouth or Ocracoke, or riding out the storm on one of the ships anchored in the vicinity, was not recorded. But this observer noted that the wind continued to increase throughout the morning and into the afternoon. Then, at 2:00 p.m., the wind veered around from northeast to west-northwest and

seemed to increase in intensity until finally beginning to die down starting approximately at 4:00 p.m. From this, we can deduce that the killer storm approached the Outer Banks from the Atlantic Ocean and made landfall somewhere in the vicinity of Ocracoke.

Several ships were damaged or destroyed in the waters in and around New Bern. A correspondent whose letter appeared in the September 15, 1775 edition of the *South Carolina & American General Gazette* compiled the following list of unfortunate vessels and their captains.

> *A sloop, Capt. Mulford, from New York, drove to Mr. Ellis's wharf, where a large breach was made in her bottom; a sloop, Capt. Doggett, from St. Croix, went ashore at Green Spring, but did not receive much injury; sloop* Sukey, *Capt. Cohran, is ashore at Bear River; ship* Harmony Hall, *Capt. Greenway, and a sloop, Capt. Bell, were drove ashore below Otter Creek the former of which has suffered considerable damage.*

A letter from an unnamed person in New Bern, dated September 9, 1775, provides a brief, but important account of the storm in eastern North Carolina. One thing that is not clear from the letter is just how extensive the damage was at New Bern. Nor is there a description of the meteorological conditions or rise in the water level of the Neuse River. The letter in question was published in the October 21, 1775

edition of the *Virginia Gazette*. The writer noted: "We had a violent hurricane the 2d instant, which has done a vast deal of damage here, at the Bar, and at Matamuskeet, near 150 lives being lost at the Bar, and 15 more in one neighborhood at Matamuskeet."

"The Bar" was not a drinking establishment. It referred to the place separating the waters of Pamlico Sound from the Atlantic Ocean at Ocracoke Inlet. Large oceangoing ships could not transport goods through here, as the depth of the channel was not sufficient. Thus, a lively trade developed as cargo from large oceangoing ships anchored on the ocean side of Ocracoke was transferred to vessels that could ply the shallow, sandbar-strewn waters of the sounds and rivers of eastern North Carolina. The process was reversed for merchandise leaving North Carolina for points abroad. This entire process was referred to as "lightering."

Because of its exposed location along the Outer Banks, hurricanes have played a big part in the history of Ocracoke, and the island is frequently mentioned in accounts of hurricanes blowing along the coast. This was especially true in the eighteenth and early nineteenth centuries, when most of North Carolina's commerce was waterborne and sailing vessels were passing through the inlet on a regular basis.

The effects of the storm of 1775 were particularly lethal at Ocracoke Inlet. The December 9, 1775 issue of the *Edinburgh Evening Courant* described the gruesome scene: "We

learn from North Carolina, that the damage done during the late hurricane is incredible, the whole shore being lined with wrecks. Upwards of 100 dead bodies had drifted ashore at Occacock Island." Unfortunately, a detailed account of how these people perished is not available. We can only surmise that the hurricane caught the people here by surprise, and the strong winds, heavy rains and a high storm surge destroyed many of the vessels waiting in the inlet before they could find shelter from the storm. We know from subsequent powerful hurricanes that the storm surge can inundate many parts of the island, leaving few places of refuge.

Ships from several distant ports were at Ocracoke when the storm struck, and they suffered a variety of damages. Of the ships that have been identified as being lost there, two came from Scotland, one from Marblehead, one from New York, one from Boston, one from Whitehaven, one from Plymouth and one from Philadelphia. Several came from home ports in the neighboring colonies of Virginia and South Carolina. But most vessels reported to be lost at Ocracoke hailed from North Carolina ports, including Wilmington, Edenton and New Bern.

Ships were also wrecked just up the banks in the vicinity of Cape Hatteras. Captain Green reported in the *South Carolina & American General Gazette*: "Capt. Parker of Pasquotank on shore at Hatteras. Capt. Drinkwater ashore. Three vessels, masters unknown, ashore at Hatteras. Captains Collier and Hayman drove off but since returned."

More casualties occurred farther up the coast along the northern portion of the Outer Banks. According to a dispatch published in *Pinckney's Virginia Gazette* on September 7, 1775, an unidentified ship was wrecked near Currituck Inlet. "We have intelligence likewise of a brig that was driven ashore at Currituck, just beyond the Capes, which stove to pieces, where two passengers and every hand on board, except the captain and an apprentice, perished."

The aforementioned letter from the correspondent at New Bern to the *Virginia Gazette* mentions fifteen people killed during the storm at "Matamuskeet." Exactly who these people were and how these individuals met their demise is unknown. Even today, this is a remote part of North Carolina, and in the eighteenth century it would have been an out-of-the-way place for people to be residing. In all likelihood, they were engaged in extracting naval stores and the other forest resources of the area.

Just across the border in Virginia, the storm played a key role in the outbreak of armed hostilities between the colonists and the British forces, and the eventual departure of Lord Dunmore, the last royal governor of Virginia. Many ships were wrecked in Chesapeake Bay by this powerful storm, including the *Mercury*, a British warship that was driven ashore on Portsmouth Point. The *Liberty*, a tender, was driven ashore nearby in Back Creek near Hampton. Colonists took advantage of the opportunity to seize the wrecked tender and plunder it of anything of value. Outraged at this open act of defiance and total disregard for royal authority, the

The Independence Hurricane of 1775

British launched a retaliatory raid against Hampton, one that ended in an embarrassing defeat for the British.

Leaving the hostilities of Virginia behind, the storm continued north up the coast. In Philadelphia, the storm was responsible for some of the highest tides ever observed in the Delaware River. Great damage was done to warehouses and wharves along the riverfront. Meanwhile, in New York City, Morgan Lewis reported that "a very heavy gale came on Saturday evening (September 2) which lasted till Sunday morning at ten o'clock."

Ludlum tracked the storm north across the mid-Atlantic colonies and into New England, where it passed on September 4. Whither it went from Massachusetts as it headed out to sea is uncertain. In all likelihood it continued on its northeasterly course and accelerated, as most hurricanes that pass through the area do. There is also the possibility that the storm moved well north from New England and dissipated over the interior portions of Quebec. Another possibility is that the storm headed out to sea, made a large loop in the Atlantic somewhere between New York and Bermuda and then returned north to strike Nova Scotia five days later. This last scenario is an extremely unlikely one, as surviving accounts from ships traveling along the coast to places such as New York and Boston mention fair weather and calm seas, not the conditions one would see from a stalled hurricane lurking off the Nova Scotia coast. It is highly doubtful that the Independence Hurricane made such a move.

These firsthand accounts of the storm's progress up the east coast demonstrate that it made its passage through New England by September 4, 1775. We can conclude that the Independence Hurricane that hammered the colonies from North Carolina to New England from September 2 through September 4 was a different event than that which struck with such lethality in the Canadian Maritime provinces on September 9–12, 1775.

The Independence Hurricane of 1775 was truly one of the most vicious hurricanes to ever plague the shores of North Carolina. The swath of destruction left behind by this potent storm has rarely been equaled, while the death toll has not yet been surpassed by any storm to strike the coast of the Old North State since.

THE TWIN HURRICANES OF 1806

The year 1806 was an active one along the Carolina coast. Two powerful hurricanes came ashore, ravaging the area between Charleston and the Outer Banks. Ships were wrecked, buildings damaged and crops ruined. Lighthouses at Hatteras and Shell Castle were temporarily put out of commission, while the lighthouse at Georgetown was totally destroyed.

The first hurricane to affect the coast that year made its presence felt in South Carolina on August 21, 1806. The storm passed by offshore, giving Charleston only a glancing blow, so damage was not particularly catastrophic. Several ships were wrecked or driven ashore in the harbor, including a United States Revenue Service cutter. Farther up the coast, at the mouth of Winyah Bay, the storm's winds blew down the wooden Georgetown Lighthouse.

One observer in Georgetown noted the conditions of the damage near his town left in the storm's wake: "The crops on

THE GREAT HURRICANES OF NORTH CAROLINA

The chart, "Map of Occacock from Actual Survey," was published in 1795 by Jonathon Price. It shows the approaches to Ocracoke Inlet in the late eighteenth and early nineteenth centuries. *Courtesy North Carolina Division of Archives and History.*

the upland have been considerable damaged, and the roads rendered almost impassable from the number of trees blown across them. Our town suffered but little damage."

The storm continued north and made landfall on the North Carolina coast on August 22, 1806, near the mouth

The Twin Hurricanes of 1806

of the Cape Fear River. At Smithville, several ships were damaged and much property destroyed, including the wharves lining the riverbank. One eyewitness in this town reported: "Happily no lives were lost, but we fear much damage has happened along the coasts and to the crops, it being allowed to be the severest hurricane and longest storm ever known here."

Upriver at Wilmington, the slow-moving storm caused widespread destruction. The winds began blowing at hurricane force on Friday morning, August 22, and continued until finally subsiding on Saturday afternoon. "We have witnessed the most violent and destructive storm of wind and rain ever before known here," a writer for the Wilmington newspaper wrote.

> *The tide rose to a height heretofore unknown; the wharves are much damaged; the loss in dry goods, salt, sugar, rice, lumber, &c. is beyond conception and cannot be ascertained. When the wind shifted to S.W. it seemed to threaten universal destruction, the gable ends of three brick houses were washed or blown down; many wooden houses were considerably wrecked and some unfinished ones entirely demolished. Mr. Isaac Baldwin was killed by the falling of an old burnt wall, and we hear that several Negroes have been killed and one drowned on plantations in the vicinity.*

One of the casualties of this storm was the *Governor Williams*, a U.S. Revenue Service cutter that was dismasted and driven ashore near Bald Head Island during the hurricane. Thomas Coles and Jonathon Price were using the vessel as they mapped the coast, and were at the time charting the Frying Pan Shoals. The other cutter, *Diligence*, was in port in Wilmington and suffered no damage. The *Governor Williams* was soon thereafter refloated, and the party continued their work, heading north up the coast to work in the vicinity of Ocracoke.

The center of the storm passed over New Bern, as an account of the storm written there notes that the winds began blowing Friday out of the northeast and "shifted about to every point of the compass. Damage at this city, however, was not extensive." Most of the fierce winds and rains apparently stayed east and south of the city.

The hurricane emerged back over the water between Cape Henry and Cape Hatteras, headed northeast up the coast. Norfolk, Virginia, reported damaging winds and heavy rains. Farther north, on the Massachusetts coast, it was estimated that the storm dumped over thirty inches of rain at Edgartown, on Martha's Vineyard.

The most notable casualty from this storm was the ship *Rose In Bloom*, which was buffeted by the heavy seas and winds while en route from Charleston to New York. It had safely passed the treacherous waters of the Outer Banks, but on Sunday, August 24, 1806, twenty miles off

The Twin Hurricanes of 1806

Barnegat Inlet, New Jersey, the ship was struck by a wave that "threw her on her beam ends." Twenty-one of the forty-eight people on board perished. In addition to the passengers, the ship was carrying a cargo of cotton, and "180,000 dollars in specie and bills, only 9,000 of which was saved."

The ordeal of the people on board the *Rose In Bloom* was related by Captain Phelan of the *Swift*, a brig from St. John, New Brunswick, that found the distressed vessel and rescued many of the survivors. His account gives harrowing and tragic details of the tragedy.

> *Among the lost, the fate of Gen. Macpherson excites singular commiseration. Both himself and daughter were washed overboard on their coming out of their cabin, being an excellent swimmer, Gen. Macpherson made the quarter railing, but perceiving his daughter struggling in the waves and just sinking, he plunged into the sea after her, seized her and brought her to the wreck, but was himself washed off a second time, and again he made out to reach the quarter, but his strength was exhausted, and he had not enough left to get on board, even with all the assistance that could be then afforded, he was drowned…*
>
> *All that could save themselves clung to the quarter railing and it was soon contrived to cut away the masts, by which she righted, but full of water and lying level with the sea. 30 bales of cotton in the hold prevented her going down.*

After the storm moved on, many vessels were discovered wrecked upon the sandy shores of North Carolina. The identities of most were unknown, as they were "broken in pieces" and their remains had been deposited on the beach. Among those identified on the Bogue Banks were the *Adolphus* and the *Atlantic*. Several unusual items washed up, including many chests containing the personal items of several hapless mariners. The pilots near Cape Lookout even found "a large keg of pickles marked Dr. O. and some packages of paper and printers ink, marked F.X.M." Folks on the Core Banks near Portsmouth made some interesting finds: "The corpse of a man who perished in the storm has drifted ashore, but so much eaten by the fishes that he cannot be known."

Just a little more than a month later, another fierce hurricane visited the coast of North Carolina. In the wee hours of the morning of September 29, 1806, another particularly strong hurricane came ashore near Ocracoke Inlet. This storm caused more damage and destruction to the Outer Banks than the previous storm.

Destruction to the ships and buildings at Shell Castle inside Ocracoke Inlet was extensive. Several vessels were dismasted, others were driven ashore. Some were even sunk by the flying debris and massive waves. One witness claimed that there were thirty vessels wrecked in Ocracoke Inlet.

An observer at Shell Castle wrote:

> *In short but one vessel in the whole navigation afloat and all standing, and that a singular instance of preservation; it is a lighter belonging to Mr. James Jones of Newbern, who struck adrift with two anchors a head, at the Castle, and drifted two and a half miles to the Royal Shoal, where she brought up and rode out the storm—only one small black boy on board.*

One of the vessels lost at Shell Castle was the *Governor Williams*, the cutter that had been dismasted and driven ashore in the previous month's hurricane in the vicinity of Cape Fear. It went down with the loss of three crewmen. Also on board were the notes and charts compiled by Colonel William Tatham, one of three men surveying the North Carolina coast at the time. Tatham had put his belongings aboard the cutter and proceeded in a whaleboat to New Bern. The value of his instruments was later calculated to be more than $1,000. The information he lost from the books and charts that went down with the ship could not be replaced.

His associates, Price and Coles, were on board the U.S. Revenue Service cutter *Diligence*, and they had their own misadventure. After refloating the *Governor Williams* in August, they headed up the coast to meet Tatham and to survey the coast near Cape Hatteras. The *Governor Williams* remained in port, but the two men headed out on the other cutter to

investigate the Wimble Shoals. Arriving at Ocracoke Inlet just as the storm broke, the *Diligence* cast anchor off Shell Castle. But the winds drove the ship a mile to the southwest, where it smashed against a schooner. The damage from the collision caused it to sink. All but one of those on board escaped to the schooner, where they rode out the terrible storm.

In their official report, Coles and Price wrote of their ordeal:

> *Mr. Coles was on board the* Diligence *when she sank, consequently lost all his instruments, papers, and every article of clothing. The officers and crew as well as himself were as early as possible taken off the wreck, by the humane exertions of the inhabitants of Shell Castle.*

Hatteras experienced the full fury of this storm. One witness described the storm surge and winds that battered the island:

> *The wind blew with such violence as to occasion the tide's rising two or three feet into several of their houses, and it was expected that a few hours' continuance of the gale would prove fatal to every person there. The wind was so astonishingly severe as to twist sturdy oaks, of the thickness of a man's body, from their roots, and scatter the limbs in the air to a great distance. All the boats in the inside of the Banks, as far as the eye could discover, or as our informant heard of, were either dismasted, overset or otherwise totally lost.*

The Twin Hurricanes of 1806

The lighthouses along the Outer Banks suffered considerable damage during this hurricane. A witness described damage at the lighthouse on Beacon Island in Ocracoke Inlet: "During the gale, the oil in the lamp of the Beacon took fire, and blew out 36 panes of glass. The light of course will not be in operation for some days to come."

The Cape Hatteras Lighthouse was damaged to the extent that it was necessary to close the light for an extended period of time so repairs could be made. A contemporary account noted: "The Light-House, on Cape Hatteras, received such injury about the Cap and Lantern, as to be incapable of being lighted up at present." Notices began appearing in the *Wilmington Gazette* a week after the storm, warning mariners of the change so they would not mistakenly crash upon the darkened banks while looking for the lighthouse.

The storm continued up the coast and headed back out to sea after passing Chesapeake Bay. Off the Virginia Capes, several French vessels were damaged and forced to seek repairs in Norfolk. Several ships from local ports were also damaged by the high winds and raging seas.

The storms of 1806 left a path of destruction along the coast, from Charleston north to Chesapeake Bay, that was not soon forgotten. To have two such destructive and ferocious hurricanes ravage the coast was a noteworthy, though not unprecedented, occurrence. For many along the Carolina coast, these twin hurricanes remained the benchmark storms against which other hurricanes of the early 1800s were measured.

THE GREAT NORTH CAROLINA HURRICANE OF 1815

In early September of 1815, eastern North Carolina was a scene of utter devastation. Along the coast, shipwrecks littered the sandy shores from Cape Fear to Currituck. Inland, crops were drowned, forests flattened, gristmills carried away and roads washed out from Wilmington to Washington. The inhabitants of New Bern watched helplessly as storm-driven waters of the Neuse River rose into their city and pounded parts of it to rubble. All of these calamities were the result of a fierce hurricane, one of the most destructive storms ever to strike the North Carolina coast.

Two powerful hurricanes battered the East Coast of the United States in September of 1815. The Great September Gale, the most widely known of these hurricanes, was the second of these storms to make landfall. It struck New England and was extensively chronicled in the press of that region, thus it is more famous. But its predecessor was the more important and destructive storm along the Carolina coast.

The Great Hurricanes of North Carolina

Numerous vessels wrecked all along the Outer Banks.

In New Bern, the storm was especially violent. "The rain drove in torrents, the wind blew a hurricane, a prodigious swell was running, some buildings falling to pieces, the sea beating against others with a fury surpassed only by the breakers on our seashore."

Water rose eight feet in Washington.

Over thirty vessels wrecked near Ocracoke.

"The sea rose so high in Fort Hampton as to endanger the lives of the men, and the barracks outside the fort was actually afloat some time with the people upon its roof."

Storm makes landfall near Swansboro on September 3rd, 1815.

The Great North Carolina Hurricane of 1815 cut a swath of destruction across eastern North Carolina.

The Great North Carolina Hurricane of 1815

This storm was called the Great North Carolina Hurricane of 1815, as the destruction meted out on the Old North State was quite severe, even by the standards of people who were accustomed to dealing with powerful equinoctial storms. Information about the early days of this storm's existence is sketchy, as there were no official weather reports or satellite images in those days to track the progress of a storm. No one knows exactly where the storm originated—perhaps off the coast of Africa, where so many of the hurricanes that affect our coast originate that time of year.

Regardless of where it began, the Great North Carolina Hurricane made its first contact with the southeastern United States along the South Carolina coast on September 1, 1815, as it approached the bustling port city of Charleston. Many ships were tossed about on the rough seas, and several wooden sailing vessels were cast up on Sullivan's Island. High winds and heavy rains caused damage to much of the cotton and rice crops growing in the low-lying coastal areas of South Carolina from Charleston north to Georgetown. The eye of the storm, however, remained well offshore as the storm passed on to the north.

As it headed north, the hurricane took aim at the Cape Fear coast of North Carolina. Fortunately for the inhabitants of Brunswick and New Hanover Counties, they received only a glancing blow as the center veered slightly eastward and remained at sea, brushing past Bald Head Island on its northerly course. There are no firsthand accounts of

the storm as it passed near what was then a remote barrier island, but the hurricane must have been keenly felt by anyone on Bald Head Island at the time.

Nearby, at the port city of Wilmington on the Cape Fear River, many buildings were damaged, including the Cape Fear Bank, whose chimneys were blown down. A correspondent for the *Wilmington Gazette* observed: "The Wharves have been somewhat injured, a Sloop from Bermuda sunk and a Brig forced from the wharf and driven some distance below Mr. Campbell's Plantation." Despite these scenes of destruction, no fatalities were reported from Wilmington during this storm.

The saltworks just east of the city on nearby Masonboro Sound and adjacent barrier islands suffered extensive damage. The storm surge was reported to have risen as high as fourteen feet, and it washed away thousands of pounds of salt. The value of the damaged machinery and lost salt was estimated at nearly $60,000.

This powerful hurricane continued traveling just to the east of north, making landfall on Sunday, September 3, 1815, somewhere along the Onslow County coast between Topsail Island and Swansboro. The destruction in the vicinity of Bear Island and the White Oak River was extensive. "At Swansborough the Storm raged with great violence," one observer noted.

> *Two schooners were lost on the Bar and two driven ashore, a ship belonging to Messrs. Burns and Pigot and*

THE GREAT NORTH CAROLINA HURRICANE OF 1815

a schooner to a Mr. Jones were taken off the stocks and driven some distance in the woods. At the Sound below, Ward's Salt Works were totally destroyed. On Brown's Bank a house occupied by Mr. Nelson and family, was washed away, his wife three children and an orphan child were drowned, himself and one son escaped on a part of the wreck, which was driven 10 or 12 miles as far as Stone's Bay. Another House in the vicinity belonging to Mr. Evans, was also washed away. Two white women and a black man and a woman perished in it.

The remains of a schooner were found washed up on the shore near the mouth of New River. No survivors were ever located, nor were any papers found to help identify the wreck. What was found with the ship was a quantity of cheese, and based on the presence of this type of cheese, the discoverers of the wrecked ship theorized that it had sailed from some New England port.

The Outer Banks did not escape the fury of this powerful hurricane. At Beaufort, many buildings on the waterfront were damaged, and some ships under construction in town were destroyed. Not far away, along the Shackleford Banks and Bogue Banks, many vessels were wrecked.

On the eastern end of Bogue Banks, Fort Hampton stood watch over Beaufort Inlet where Fort Macon stands today. The fort was in danger of being inundated by the massive storm surge accompanying this hurricane.

One correspondent noted: "The sea rose so high in Fort Hampton as to endanger the lives of the men, and the barracks outside the fort was actually afloat some time with the people upon its roof."

Farther up the coast, over thirty vessels were counted wrecked upon the beaches in the vicinity of Ocracoke. Six crewmen were washed from the deck of the brig *Julia* before the ship was driven ashore and destroyed in the pounding surf along the beach between Hatteras and Ocracoke. Still farther up the coast, an untold number of ships were cast upon the sandy shores in the vicinity of Cape Hatteras.

The beaches and barrier islands were not the only places to feel the power of this hurricane. As the storm headed inland, its savage winds flattened thousands of trees and damaged countless structures across the rural countryside. Many hapless farmers watched helplessly as floodwaters from the torrential rains inundated fertile bottomland, where crops were nearly ready for harvesting.

The city of New Bern was especially hard hit by this storm, and seldom has any hurricane been so destructive there. As might be expected with a storm bearing down on the North Carolina coast, Sunday, September 3, 1815, was a rainy, windy day in Craven County, but after nightfall the weather took a serious turn for the worse. The east wind blowing on the northern side of the hurricane backed the waters of the Neuse River up into town, where residents awoke on September 4 to find six feet of water in the streets.

The Great North Carolina Hurricane of 1815

One witness at New Bern penned an account of the storm for a Raleigh newspaper called *The Minerva*. This unnamed correspondent observed:

> *The rain drove in torrents, the wind blew a hurricane, a prodigious swell was running, some buildings falling to pieces, the sea beating against others with a fury surpassed only by the breakers on our seashore: and amidst all these horrors were seen families struggling to escape from their houses, and persons striving to save their property! By ten o'clock on Monday, the wind shifted to the southward and abated, and the water gradually receded.*

As the storm continued its northeastward journey, it passed near the town of Washington, on Pamlico River. Another correspondent for *The Minerva* noted that the wind-driven waters rose along the waterfront at Washington at a rate of fifteen inches an hour, cresting at a height of eight feet before the wind shifted and the water level dropped. "During the blow, great quantities of naval stores, lumber and other properties were swept from the wharves and taken off with the tide," he observed. "Several vessels broke from their fasts, two of which are ashore."

The hurricane continued on a northeastward track, crossing Chesapeake Bay and passing out to sea in the vicinity of Norfolk, Virginia, on September 5, 1815. From there it continued on, running parallel to the

coast and bringing gale-force winds to New York and Massachusetts.

For the residents of New England, this was a prelude of things to come. Fortunately for the folks in North Carolina, the hurricane known as the Great September Gale of 1815 passed them by, leaving them undisturbed as they cleaned up the mess left in the wake of the Great North Carolina Hurricane of 1815.

THE GREAT NORTH CAROLINA HURRICANE OF 1827

A dozen years after the memorable hurricane of 1815 made landfall along the North Carolina coast, another powerful hurricane came ashore in the Old North State. The Great North Carolina Hurricane of 1827 left behind a swath of destruction across much of the state, and it was believed by many who lived through it to be an even more potent storm than the aforementioned hurricanes of the early 1800s. Its effects were widespread, and reports of damage resulting from winds and floods came in from as far west as Forsyth County.

"There is little doubt that this was a *great* hurricane with destructive winds, extraordinary tides, and very heavy rainfall, and that all of these elements covered an unusually large geographical area," observed weather historian David Ludlum. "It must be accorded a place in top rank among North Carolina storms."

This appears to have been a classic example of a Cape Verde Storm, and it first made its presence felt in the Lesser

Antilles on August 17 and 18. The hurricane then moved to the northwest as it made its way through Haiti and the Bahamas, and it was off the coast of South Carolina by August 24.

This hurricane made landfall somewhere in the vicinity of the border between North and South Carolina, much like Hurricane Hazel would in 1954. Based on descriptions of wind conditions in Wilmington, Ludlum points out that the center of the storm passed just to the west of the port city as it made its way across eastern North Carolina. In the Wilmington area, damage was widespread and extensive. The winds and storm surge widened the inlet entering Masonboro Sound by half a mile. But the waters also destroyed several of the saltworks that operated here making salt from the briny waters of the sea.

The city itself suffered some damage, but nothing catastrophic. A few buildings lost their chimneys, roofs were blown away and fences were blown down. But there were few ships in port when the storm struck, so damage to the shipping was minimal, with just less than a dozen vessels being driven ashore along the banks of the Cape Fear River.

The winds and torrential rains from this powerful storm reached as far west as Bethabara, in Forsyth County, near the modern site of Winston-Salem. There, a witness reported the storm blew down fences, tore away roofs and damaged orchards and forests. Many bridges over inland creeks were carried away by the floods that resulted from the storm. There were also many roads washed out that impeded travel for several weeks after the storm passed.

The Great North Carolina Hurricane of 1827

The effects of the storm were severe at Washington, where water rose up to six feet in some parts of town. The shipping along the waterfront suffered many losses to the town's port facilities and docks were destroyed. One witness said of this hurricane:

> *It was more violent than the memorable one in 1815; a schooner was left high and dry on the wharf at Washington, and others drove against the bridge and carried it away. There is but one mill left standing within 10 miles of this place. The crops generally have been destroyed.*

Losses to shipping at Ocracoke were not as extensive as they could have been thanks to the fact that there were only half a dozen vessels on the sound side of the island in Wallace's Channel when the storm struck. Of these six, five were driven across Teaches Hole and grounded on Ocracoke, while the sixth was blown into the open waters of Pamlico Sound. There were quite a few vessels on the ocean side of the inlet, and at least twenty were reported to have washed ashore in the vicinity of Portsmouth.

Ships from all over the world littered the North Carolina coast from Cape Fear to Currituck after this powerful hurricane had passed on. Most were schooners from North Carolina and adjacent waters. There were several vessels from New York, and at least one from London.

> Notice.
> WILL BE SOLD
> AT PUBLIC AUCTION.
> On Monday the 10:h of September on the beach, at Body's Island, 4 miles north of New Inlet, the remains of the cargo of the Ship Louisa Matilda, from New-York for Savannah, consisting of sundry valuable articles, with the Rigging, Sails, &c.— All to be sold to the highest bidder without reserve.
> ABRM. B. CARY, Master.
> Aug. 27.

Sometimes when ships were stranded by storms along the remote stretches of the Outer Banks, their captains would auction off the goods. This notice for one such auction was published in the *Elizabeth City Star and North Carolina Eastern Intelligencer* on September 1, 1827, by Captain Abraham Cary, who lost his ship on Bodie Island during the Great North Carolina Hurricane of 1827.

The Great North Carolina Hurricane of 1827

At Cedar Hummock, just north of Cape Hatteras, a large ship with an unusual cargo came ashore during the height of the storm: "A large brig from the Bay of Honduras, laden with Cochineal, Indigo, Mahogany and Specie, bound to London." This exotic and valuable cargo was saved from the local wreckers and presumably made its way to London once the ship was refloated.

The *Amphibious*, a schooner sailing out of New Bern, was one of the ships wrecked on the beach near Portsmouth. The body of Captain Major, who commanded the vessel, drifted ashore later. Farther up the banks, Captain Tolson, of the schooner *Mary*, suffered a similar fate when he was washed overboard from his ship into the storm-tossed waters of the Atlantic, where he drowned. Whether his body ever washed ashore was not recorded.

The schooner *Blakely* put out to sea from its home port at Elizabeth City and encountered the storm off the northern Outer Banks between Cape Hatteras and Currituck. It was tossed about on the seas for four days in the storm. The ship's freshwater supplies were fouled, and at least three crewmen became ill. Finally, after springing a leak, the captain was forced to return the *Blakely* to port. Captain Ethridge, who had been sailing in these waters for four decades, reported that he had never experienced such a fierce storm as the 1827 hurricane.

Perhaps the most famous casualty of this hurricane was the Diamond Shoals lightship. The vessel was placed thirteen

and a half miles off the tip of Cape Hatteras in the summer of 1824, and marked the treacherous waters of the Diamond Shoals. Captain Leif Holden was captain of the vessel in the summer of 1827, and he was accompanied by his wife and daughters. With the ship's mate and four crewmen, conditions on the lightship must have been quite cramped.

To add excitement to the monotony of floating in the same spot, day in and day out, the ship was frequently battered about by storms. At the height of the Great Hurricane of August 1827, the Diamond Shoals lightship broke loose from its moorings and was driven ashore on the Core Banks near Portsmouth. Two crewmen, the carpenter and the ship's mate were washed from the vessel and drowned in the Atlantic. Everyone else made it safely ashore. It would be over half a century before another light vessel was placed along this dangerous spot in the infamous "Graveyard of the Atlantic."

After leaving North Carolina, the hurricane headed northeast, passing back out over the Atlantic somewhere in the vicinity of Norfolk. The storm grazed the New England coast, where it brought heavy rains and gale-force winds to New Haven, Nantucket and Cape Cod. In its wake, the Great Hurricane of 1827 left a path of destruction comparable to other powerful hurricanes that were chronicled in the nineteenth century. Because of its massive size, ferocious winds and notable flooding, this potent storm was long remembered as one of the most powerful hurricanes to plague North Carolina.

CHARLIE TIEGEN'S HURRICANE OF 1856

In August of 1856, the southeastern United States was hammered by three ferocious hurricanes that brought death and destruction to the coast from Louisiana to North Carolina. The most famous of the trio was the Last Island Hurricane, which claimed over five hundred lives as it roared ashore and destroyed a popular Louisiana coastal resort. The second hurricane came ashore in the Florida Panhandle near Cape San Blas, devastating much of that region before moving inland and stalling. But the most powerful of these hurricanes was the one that came ashore along the Cape Fear coast on August 31, 1856, packing destructive winds, heavy rains and an unprecedented thirty-foot storm surge.

Communications in the days prior to television, radio and the Internet were slow by modern standards, especially in areas devastated by major storms. Often it took several days before word of the destruction caused by a natural disaster such as a major hurricane reached the outside world. This was especially

true of the accounts of the hurricanes of August 1856, when news of one hurricane was only just being reported as another storm threatened the southeastern United States.

In addition to sluggish communications, there were severe limitations in techniques for tracking hurricanes. Most hurricane tracks were mapped long after the storm had passed by analyzing observations from ships' logs that had weathered the storm, or from observers on the ground near the path of a storm. Hurricane Hunter aircraft and satellite imagery were still more than a century in the future. With these facts in mind, it is easy to understand how it was possible for most of those who chronicle hurricane lore to confuse the major hurricane that struck near Cape Fear, North Carolina, with another powerful hurricane that came ashore less than forty-eight hours earlier on the Florida Panhandle near Cape San Blas.

The Last Island Hurricane was perhaps the best chronicled of the storms that battered the coast of the southeastern United States during the summer of 1856. On August 9, 1856, a powerful hurricane approached the coast of Louisiana from the Gulf of Mexico. Vacationers at the resort on Isle Dernier (Last Island) on Caillou Bay off the southern coast of Louisiana noticed an increase in intensity of waves pounding the beaches. At that time, there were between four hundred and five hundred people on the island, which at its highest spot was only about ten feet above sea level.

On the morning of August 10, 1856, the storm struck with all its fury. Winds estimated as high as 130 miles per hour drove

Charlie Tiegen's Hurricane of 1856

heavy rains that lashed the island and its residents. W.W. Pugh, Speaker of the House of Representatives for Louisiana, was on the island when the storm struck. He noted: "The water was blown with such extreme violence, that you were partially blinded by the salt spray, and when it came in contact with the face, it felt as if you had received a charge of small shot."

Of greater importance, however, was the thirteen-foot storm surge that accompanied this hurricane. The rising waters completely inundated the island, sweeping it clear of all structures. The island's largest structure, the Muggah Billiard House, was destroyed, but many of its occupants were saved when they sought shelter on board the steamer *Star*, which had been driven ashore prior to the building's collapse.

The storm continued inland, spreading destruction across southern Louisiana. There was much damage to buildings and other structures, especially along the docks in New Orleans. Farther inland, crops were severely damaged by the hurricane. Though deaths from the storm totaled approximately 150, this was not an extremely high number of casualties by nineteenth-century standards. The more lasting effect of the Last Island hurricane was the storm's psychological impact on the people of the South. Stories of suffering told by those who survived, as well as gruesome tales of individuals looting the dead, captured people's imaginations for years afterward. Historian James Sothern observed:

> *Last Island, unlike the other communities along the coast, was a popular resort visited by well known, prominent people from throughout the state. When news of the disaster reached the mainland, it caused widespread grief and concern, so much so that the impetus created by this tragic episode lingers on until today.*

Following close on the heels of the Last Island Hurricane was another severe hurricane that took aim at the Gulf Coast. As this storm moved west across Cuba on August 27–28, 1856, it inflicted great damage and numerous casualties. Havana recorded a barometric pressure of 28.62 inches. From Cuba, the storm curved north into the open waters of the Gulf of Mexico, brushing past Key West, Florida. At latitude 26° 30′ north and longitude 87° west, the ship *Daniel Webster* encountered this storm and recorded a barometric pressure of 28.60 inches.

The storm quickly crossed the Gulf of Mexico, and on August 30, 1856, it made landfall on the Florida Panhandle near Cape San Blas. Storm waters cut across the peninsula of land separating the waters of St. Andrews Sound and the Gulf of Mexico, creating a new inlet—Hurricane Inlet—and a new island, aptly dubbed Hurricane Island. Both landmarks have survived into the present era, though the inlet is now more commonly known as West Pass.

The hurricane brought its strong winds, heavy rains and storm surge ashore at Apalachicola, beginning on the evening of August 30, 1856. The waters flooded the commercial

CHARLIE TIEGEN'S HURRICANE OF 1856

district and peaked in the predawn hours of August 31. One correspondent for a New Orleans newspaper noted that the storm was fierce, though the flood from the surge did not quite measure up to a particularly destructive hurricane that had struck Apalachicola five years earlier.

Like the Last Island Hurricane, the Cape San Blas Hurricane was reluctant to leave the area. Reports indicate that the storm spent its fury over western Florida, southern Georgia and Alabama. Richard Henning, staff meteorologist of the Forty-sixth Weather Squadron at Eglin Air Force Base, noted that "after landfall, this storm stalled over the Panhandle for six days and winds destroyed most of Marianna and Milton."

Precipitation from this storm spread inland, soaking portions of Georgia, Louisiana, Mississippi, Alabama, South Carolina and southern North Carolina. Rivers across the region swelled beyond their banks as the rain poured down and the storm's forward progress slowed. Destruction from the winds of the Cape San Blas Hurricane was experienced as far inland as Columbus, Georgia.

North Carolina was on the outer fringes of the heavy rains associated with the Cape San Blas Hurricane. The storm made itself felt in the southern and western portions of North Carolina, where heavy rains began falling on Saturday, August 30, 1856, and continued into the next day before they subsided. But, the break was only temporary.

Like much of the southeastern United States, Wilmington was visited by the heavy rains associated with the Cape San

Blas Hurricane. By Sunday afternoon, precipitation from this storm tapered off in the port city, and there were no indications that a new storm was approaching from the Atlantic. After nightfall, however, a fast-moving storm blew in off the Atlantic and struck the Cape Fear coast with all its fury.

Describing the storm on the Monday after the event, a writer for the *Wilmington Journal* noted: "Last night and this morning it rained and blew terribly, in fact, a perfect tempest. We hardly recollect to have listened to heavier gusts than those of last night." This unnamed correspondent for the *Wilmington Journal* described the wind conditions: "In the course of last night the wind veered round from north or northeast, to south or southeast, blowing onto the coast, and giving every reason to fear for the safety of shipping." This change in wind direction indicates that the storm came ashore in the vicinity of Cape Fear, arriving from the southeast and moving inland. The storm quickly traveled across the eastern portions of the state in the wee hours of the morning on September 1, 1856, and was in the vicinity of Chesapeake Bay and Norfolk, Virginia, by first light of that Monday morning.

The storm surge that accompanied this storm as it made landfall along the Carolina coast was enormous. Nearly eighty years after the event, Wilmington Weather Bureau Chief Reuben Frost gathered accounts from residents whose parents and grandparents had passed along information about this storm. Among the more interesting accounts are descriptions of the ocean's breakers washing over Wrightsville

Charlie Tiegen's Hurricane of 1856

Beach and breaking half a mile inland on the mainland near the home of Charlie Tiegen. He therefore dubbed the storm "Charlie Tiegen's Hurricane."

Frost described the scene at Wrightsville Beach as this powerful storm came ashore:

> *Wrightsville Beach was then half a mile wide and had many large live-oak trees. The storm washed away most of the oak trees and those remaining died soon after the storm. There were no buildings on Wrightsville Beach, just a few fishing shacks. The trees, wrecked shacks and other debris floated across the Sound into Tiegen's yard. The breakers broke around the live-oak trees in Tiegen's yard which was half a mile from the Sound and 30 feet above sea level.*

A 30-foot storm surge would be a truly remarkable event, one that rarely has been seen anywhere on the planet and eclipses the storm surge measured in some pretty famous Category Five hurricanes of the twentieth century. The Labor Day Hurricane of 1935 is credited with creating a 20-foot storm surge in the Florida Keys. In 1969, Hurricane Camille came ashore in Mississippi with a storm surge of 24.4 feet. The highest storm surge ever recorded in the world was the 42-foot surge that occurred in Bathurst Bay in Australia back in 1899. If Frost's calculations are correct, the 30-foot storm surge was among the most remarkable storm surges ever witnessed.

THE GREAT HURRICANES OF NORTH CAROLINA

To give a different perspective of just how powerful Charlie Tiegen's Hurricane was, it is helpful to compare it with the most powerful hurricane to strike the same region in the recent past. The storm surge for Hurricane Hazel, which came ashore along the North Carolina/South Carolina border in 1954, was seventeen feet, just a little more than half as high as the thirty-foot storm surge calculated for Charlie Tiegen's Hurricane. Photographic evidence provides mute testimony to the destruction wreaked upon the barrier islands of Brunswick County, North Carolina, during Hazel. One can only imagine the destruction a thirty-foot storm tide would wreak in the early twenty-first century if it stripped Wrightsville Beach bare, not of oak trees but of condominiums.

Conditions farther south along the coast at New Inlet were almost as bad as at Wrightsville. Waters from the storm surge nearly washed away Zeke's Island, along with the workers quartered there constructing navigational improvements on New Inlet. A correspondent for the *Wilmington Journal* noted that the region had narrowly averted a "Last Island affair" at this site. His report continued:

> *But a small margin of bare sand was left between the raging swell of the ocean and the buildings erected for the residence of the persons engaged upon the works at Zeke's Island. The "oldest inhabitant" having been hunted up, and questioned on the subject, knew nothing like it within his recollection. The view of the ocean roaring over the*

Charlie Tiegen's Hurricane of 1856

sandy beach, tumbling in and breaking into snow-white foam, was grand but terrific, especially to those occupying the small patch of sand which alone remained visible to represent Zeke's Island. The works stood the test perfectly.

Inland, the rains from two tropical cyclones caused raging floods along the creeks and rivers of the state. A report from the *Fayetteville Observer* notes that bridges and dams along the creeks in the vicinity of Cumberland County were carried away by the rising waters. In addition, bridges along Upper Little River in Harnett County were washed away.

The waters of Rockfish are higher by 6 feet, it is said, than ever before known; and the Cape Fear Fresh is said to be greater than any since 1840. Of course all the low lands are overflowed, and we must expect to hear of great damage to the corn and rice.

Upstream from Fayetteville at Haywood in Chatham County, where Deep and Haw Rivers unite to form the Cape Fear River, an unnamed correspondent penned a letter to the *Wilmington Daily Herald* describing conditions on September 1, 1856:

We are surrounded by water. The Rivers are higher than for several years. The bridge across Deep River at Lockville, broke this evening at 3 o'clock, and took off one of the arches of our bridge. 9 o'clock, P.M.—The river is still rising. I feel

there will be great damage to the corn crop. The only good corn in this vicinity is immediately on the river low grounds.

The rising waters spelled trouble for the Cape Fear & Deep River Navigation Company. The raging waters from the freshet caused considerable damage to their newly erected navigation works along the Cape Fear and Deep Rivers between Fayetteville and Gulf. The most extensive damage seems to have been to the Red Rock Lock and Dam near Averasboro in Harnett County, and the Silver Run Lock and Dam near Old Bluff in Cumberland County.

Farther inland, the heavy rains from this storm washed out the railroad embankment along the North Carolina Railroad near High Point. West of there, between High Point and Salem, water damaged the Fayetteville & Western Plank Road to the extent that it was impassable to stages for a few days.

As the storm sped northeast across North Carolina, it spread its winds and heavy rains northward. New Bern was isolated from news from the rest of the state for at least three days thanks to the raging floodwaters of the Neuse River and its tributaries. The bridge over Bachelor's Creek was carried away by the torrent, severing one of the main transportation and communication lines with the interior of the state. "This will account for the present derth of news in this week's issue," the editors of the local newspaper explained.

Before leaving the mainland and heading back out to sea, the storm took aim at southeastern Virginia, where it

was compared in intensity with a storm that had struck ten years earlier. According to accounts gathered by the National Weather Service at Norfolk, the storm caused a variety of damage. "At Norfolk, the storm was considered an equal of the 1846 hurricane. It began at 4 a.m. and raged throughout the day. The spire of the Baptist church was blown off," while the navy yard at Portsmouth received "much damage."

The hurricanes of 1856 brought to a close the wild weather that had plagued the South for the entire year. In January, the eastern United States experienced the most intense winter weather outbreak ever recorded. Many rivers and lakes in the Carolinas froze over for several weeks. Ice flows were widespread on the Mississippi River as far down as Tennessee and Mississippi. Many individuals died from exposure in northern Florida. One of the most massive snowstorms ever to strike the Carolinas and Virginia occurred, causing much destruction. The cold winter was followed by a severe drought across the Southeast and the Midwest. In many of the states, crops were stressed, and it was reported that the only good corn crops were growing along the river bottoms. This was an unfortunate situation that led to much suffering as the raging waters unleashed by the hurricanes of August flooded out the corn crops.

This wild combination of severe weather, particularly the droughts and hurricanes, had a lasting economic impact on a significant potion of the United States that may have spawned even more far-reaching political implications. Cotton

was one of the most important money crops grown in the nation and it played a key role in the economy of the United States. Much of the cotton crop from the 1855 season from Louisiana, Mississippi, Tennessee and Arkansas was still on the docks in New Orleans awaiting shipment to Europe when the Last Island Hurricane struck, destroying many of the city's shipping warehouses, which were full of cotton. This storm destroyed crops in southern Louisiana and Mississippi. Farther east, much of the 1856 cotton crop was stressed by the severe drought of the early summer. What cotton managed to survive from Alabama and Florida up through North Carolina was next subjected to the massive floods and winds of the Cape San Blas and Charlie Tiegen's Hurricanes. The effects from these natural disasters were felt all across the country as these assaults on the region that grew the nation's most important cash crop were followed in 1857 by a financial panic that was felt in some regions through 1860. Ironically, the depression was more keenly felt in the Northern states, where industry suffered, unemployment grew and thousands of businesses across the country went bankrupt.

For a natural calamity that was so powerful and whose impact was so far reaching, it is ironic that the great hurricane that struck the Cape Fear coast in 1856 is not more widely known. But in the excitement and chaos that followed five years later, most people seem to have forgotten the remarkable storm. Fortunately, Reuben Frost rescued the storm from oblivion and gave it a name—Charlie Tiegen's Hurricane.

The Great Beaufort Hurricane of 1879

The Great Beaufort Hurricane of 1879 left a path of destruction seldom equaled along the Carolina coast. This massive storm brought heavy rains and catastrophic winds to the North Carolina and Virginia coasts from Cape Fear north to Cape Charles. Wind speeds measured during this memorable storm set a record for the highest maximum sustained winds officially recorded in a hurricane along the North Carolina coast, a record that has stood for more than 125 years.

This hurricane was a Cape Verde–type storm that originated in the eastern Atlantic in early August of 1879. The track of the storm took it north of the Caribbean Islands and into the southern portion of the Bahamas by August 15. The storm took a northern turn, skirting the eastern edge of the Bahamas as it took aim at the coast of the southeastern United States.

By August 16, 1879, the hurricane continued to curve north and eventually to the northeast, a move that spared South Carolina but meant trouble for the folks in North Carolina.

The Great Hurricanes of North Carolina

The U.S. Army Signal Service's weather observers were posted inside the keeper's quarters at the Cape Lookout Lighthouse when the Great Beaufort Hurricane of 1879 struck the North Carolina coast. Maximum sustained winds of 138 miles per hour were the highest officially measured during a hurricane along the North Carolina coast. *Photo courtesy National Park Service, Cape Lookout National Seashore.*

On the eighteenth, the powerful storm passed a short distance offshore from Cape Fear as it skirted the coast and made landfall in the vicinity of Topsail Island and Swansboro. Much damage was inflicted at Wilmington, including roofs blown off houses, streets flooded and trees downed in the streets. Many boats were tossed about and wrecked in the Cape Fear River. Despite all this damage, Cape Fear was spared the effects of the worst part of the storm.

Looking back on the storm nearly eighty years after it visited our state, Reuben Frost observed that this was one of the most destructive storms to ever visit the area:

> *The damage done by this storm cannot be enumerated. The damage to maritime property must have been*

The Great Beaufort Hurricane of 1879

enormous; reports at hand show that over one hundred large vessels were shipwrecked or suffered serious injury, while the number of yachts and smaller vessels which were destroyed or seriously damaged must certainly exceed two hundred. The journal of the Wilmington Weather Office gives a detailed account of the destruction in the city and to ships in the vicinity. This was most certainly one of the Great Hurricanes that have struck the southeastern North Carolina coast.

The damage to shipping as a result of this hurricane was widespread, reaching up the entire Atlantic seaboard from Florida to Nova Scotia. A discussion of just a few of these damages demonstrates the hardships and sheer terror endured by those who encountered this powerful storm on the high seas.

The *Hera*, a German bark en route from Singapore to New York City, came in on the backside of the storm and encountered the *Forest City*, a bark that was badly damaged as a result of the hurricane. When the *Hera* came across the stricken vessel, it presented quite a scene:

The bark had become literally full of water on the 20th, and but for her cargo of timber she would have gone to the bottom long before. As it was, the timber was working badly, and there was some danger of this causing the vessel to break up.

Captain Grimm of the *Hera* offered to take the crewmen of the *Forest City* off their water-soaked vessel, but its captain declined, as he believed they could hold out and limp into a nearby port.

Scores of ships suffered a similar plight as that of the *Forest City*. Some men were lucky enough to survive aboard damaged vessels until help could arrive. Others were not so fortunate. The steamer *City of Columbus* reported passing a rather good-sized ship turned upside down several miles off the Outer Banks, its copperplated bottom exposed above the surface and its sailing rigging floating nearby. There was no sign of any survivors of the ill-fated vessel.

Shipwrecks were reported all along the Carolina coast. On the August 18, the bark *North Carolina*, with Captain Buchan commanding, was overtaken by the storm along the northern reaches of the Outer Banks. A British ship that plied the waters off the Carolina coast, it was a fairly new ship, making just its fifth passage between Wilmington and Baltimore. The iron-hulled vessel struggled against the storm, but was eventually wrecked along the northern reaches of the Outer Banks just across the Virginia border near Life-Saving Station No. 4. The ship was tossed up onto the sandy banks in such a fashion that all hands escaped without injury. Its owners were lucky, and the vessel was repaired and refloated in short order.

The *Marion Gage*, a three-masted schooner loaded with lumber, was reported to have wrecked ten miles off New Inlet, near Bald Head Island. It was under the command of

The Great Beaufort Hurricane of 1879

Captain Cane, en route from Apalachicola to Philadelphia, when it encountered the storm. The fate of this vessel is unknown. Another vessel, the *Arietta*, a yacht belonging to J.T. Flowers, was caught in the storm near Cape Fear. After a wild ride, it was deposited in the marsh just north of Bald Head Island.

The *Lorenzo*, a schooner loaded with naval stores, was just one of several vessels destroyed in the waters of Onslow County. Many of the vessels engaged in running naval stores between New River and the Cape Fear were known as "corncrackers," and witnesses reported that the entire "corncracker fleet" had been damaged or destroyed in the storm. Tossed about like a toy in the turbulent waters of the New River near Jacksonville, the *Lorenzo* sank during the height of the storm.

Along the coast in Carteret County, damage to shipping was extensive. "Every boat in the harbor was capsized, and either rolled over on the beach, or was carried off," observed a correspondent from the *Raleigh Observer* who visited Beaufort the day after the storm and was an eyewitness to the destruction wrought upon the shipping in that port.

> *It is impossible to estimate the amount of damage done. A large two-masted sloop was carried about two hundred yards up into town and left there by the waves. The man-of-war, anchored in the harbor, was run ashore; what damage she sustained we were unable to find out.*

Whereas Wilmington was on the side of the hurricane that is generally the weakest, Beaufort, Morehead City and Cape Lookout were within the powerful, right front quadrant of the eyewall. The winds at these locations were much stronger than those experienced along the Cape Fear coast, and the damage was more catastrophic. Houses, churches and at least two hotels were destroyed by this killer storm.

At Beaufort, many people had gathered in the famous Atlantic Hotel for a meeting of the North Carolina Press Association. The management was planning a gala ball for association members and their guests and was looking forward to record attendance. Among the dignitaries already on hand by the evening of the seventeenth were Governor Thomas Jarvis and his wife Mary.

The Atlantic Hotel was built in 1859 on the Beaufort waterfront. The three-story frame structure rested on pilings over the water and was obviously vulnerable to the effects of hurricanes. But when Signal Service weather observers at Fort Macon warned of the approach of the powerful hurricane in August of 1879, management chose not to share the news with its guests.

The approach of the mighty storm became apparent to all concerned in Beaufort and elsewhere along the Crystal Coast as the sun went down on August 17, 1879. Shortly after midnight, rain and winds hammered the town, and by 3:00 a.m. on the eighteenth, the storm surge flooded into Front Street.

The Great Beaufort Hurricane of 1879

By 5:00 a.m., the floodwaters had risen into the first floor of the Atlantic Hotel, and guests made the decision to seek higher ground. Out into the storm they rushed. Some, including the governor, wore only their pajamas. Shortly thereafter the building collapsed. Not everyone made it out before the structure collapsed, and several brave individuals perished in their attempts to rescue others in Beaufort. These included Henry Congleton, John Dunn and John D. Hughes, who all died while trying to rescue guests from the Atlantic Hotel.

Shortly after the storm passed, William B. Duncan of Beaufort wrote a couple of letters to his son Thomas, describing the storm and its aftermath in their hometown and its environs. Fortunately, copies of these fascinating documents have been preserved and are now housed in The History Place in Morehead City. His account mentioned scores of houses with chimneys blown down, structures floated off their foundations, businesses with a host of structural damage and the port city battered.

> *We have had a terrific storm as you are well aware. I will give you an account of the damage as near as I can. The Atlantic Hotel is entirely destroyed not one brick or plank left on top of each other at the place it formerly stood. The Barroom + ten-pen alley all gone. The Lowenburg House is nearly undermined the embankment in front all washed away and you can see*

> *the bottom of the pillars on which the house is built. Mr. White's shop was washed down…Mrs. Willis', SW Gabriel, Capt Wm Sabiston's stores washed away. C. Clauson's washed off the blocks, his wife + children in it and were rescued after the other stores mentioned had been swept away.*

Fortunately, there were some official weather observers on duty along the coast who filed reports of this great hurricane as it tore its way across North Carolina. Less than a decade earlier, on February 2, 1870, Congressman Halbert Paine introduced a resolution that provided for the establishment of a systematic observation of weather conditions at the various military outposts across the United States and along the shores of the oceans and Great Lakes. This resolution passed and was signed into law by President Ulysses S. Grant on February 9, 1870. From this legislation came the establishment of the Division of Telegrams and Reports for the Benefit of Commerce, which was officially a part of the United States Army's Signal Service. The headquarters of the organization were in Fort Myer, Virginia.

One of the new organization's duties was to provide for the reporting of the "approach and force of storms" along the seacoast and Great Lakes by means of "magnetic telegraph and marine signals." To accomplish this, the army established several weather observing outposts along the shores of the United States that were connected via

The Great Beaufort Hurricane of 1879

telegraph with the Signal Service headquarters in Virginia. By the late 1870s, a telegraph line running along the coast connected the various weather stations with each other as well as with Fort Myer.

One outpost in the Signal Service's line of stations along the shores of North Carolina was established at Cape Lookout in 1876. On March 8, 1876, Sergeant E.F. Brady officially opened the Signal Service's office at Cape Lookout. According to the Annual Report for 1876, the office was set up on the second floor of the light keeper's house. The meteorological instruments were placed on posts fifty feet to the north of the house. On October 29, 1877, these meteorological instruments were moved to a new location. The Annual Report for 1878 noted: "The instrument shelter was moved from posts fifty feet away from the building to the middle north window of the light-keeper's house."

In addition to observing the weather, Signal Service personnel at Cape Lookout were responsible for keeping the telegraph line running along the coast, "one-half way to Portsmouth and one-half way to New River, a distance of sixty-two miles," in working order. Oftentimes men stationed here were sent off on detached duty repairing the lines all up and down the coast, not just those in the vicinity of Cape Lookout.

Duty for the soldiers stationed at these remote weather observation stations was often monotonous, and since the station was manned only by one or sometimes

two people, the duty could become lonely and dull. Fortunately, the Signal Service observers at Cape Lookout had the lighthouse keepers and their families to keep them company. In addition, there was a thriving settlement of shore-based whalers, fishermen and their families residing nearby on the Shackleford Banks who occasionally dropped in on the observers.

At first, few people availed themselves of the information provided by the Signal Service at Cape Lookout. But eventually people began to take note of its warnings. The Annual Report for 1878 noted:

> *The display of cautionary offshore signals at this point is chiefly of benefit to the fishermen on the beach, enabling them to secure their nets and boats, and to small coasting vessels. During gales or the appearance of bad weather large vessels give these shoals a wide berth, and very seldom come near enough to the station to discern the signals displayed. Numerous parties from all parts of the State and Virginia visit this point during the summer months, and all take a lively interest in the service.*

The fierce storms that rage along the Outer Banks of North Carolina often added adventure to the normal routine of the weather observers. These storms strike at all times of the year, and whether they are the nor'easters of the cooler months or the powerful tropical cyclones of the

THE GREAT BEAUFORT HURRICANE OF 1879

summer and fall, they often prove to be quite dangerous and destructive. The most notable of these tempests to strike Cape Lookout while Signal Service weather observers were on hand was the Great Beaufort Hurricane. Private H.J. Forman was in charge of the Signal Service's weather station at Cape Lookout when this powerful storm came ashore, and he had the honor of observing the highest maximum sustained wind speed officially measured at sea level in North Carolina—138 miles per hour. Unfortunately, the anemometer was blown away shortly thereafter, so Forman was unable to record the actual wind speed during the height of the storm. He estimated that the wind was howling at 165 miles per hour. If Forman's estimate was correct, the Great Beaufort Hurricane has the distinction of being a Category Five hurricane, one of the few such powerful storms to make landfall in the United States.

In his report to the Chief Signal Officer in Washington, Private Forman elaborated on what he observed on that fateful day:

> *The howling of the wind and rushing of the water past the station woke us at 5 a.m., 18th. Velocity at this time being 80 miles per hour and rapidly increasing. The rain pouring down in torrents, the sea rushing past the house at a fearful rate and rising rapidly. It soon undermined the Signal Service stable, the Lighthouse Establishment store house and a cook house, which were blown down*

and carried away by the rushing tide. The Signal Service mule which became loose when the stable washed away tried to come to the dwelling house but could not face the raging storm, she turned and rushed into the foaming billows. She was found next day on Whitehurst's Island, having swam two miles. The fence around the light house next went carrying the Keeper's fuel along with it. The whaling schooner SEYCHELLE of Provincetown, Mass., 50 tons, Capt Cook, fishing in these waters was at anchor in the Hook, parted her chains, ran across Wreck Point, by almost superhuman efforts the crew got a small piece of canvas on her and the wind veering to Southwest they succeeded in running her ashore within 1/2 mile of this station where she now lies high and dry above the highest tide mark, a total loss. None of the crew were lost. At the time the vessel crossed Wreck Point she was drawing 12 feet of water, thus showing the tide to have been fuller than ever known at this place as the oldest inhabitants cannot remember of any tide ever before overflowing this point.

The anemometer cups were blown away at 6:35 a.m. at which time the register showed a velocity of 138 miles per hour, the wind continued increasing and the water continued rising until 7:35 a.m. when the velocity was estimated at 165 miles per hour. It had veered to SW and commenced abating, the tide was falling, the barometer rising and the darkness which had enveloped us was

The Great Beaufort Hurricane of 1879

slowly lifting and gladly we hailed the appearance of light, which some here never expected to see in the land of the living.

Anemometers at the other weather stations along the Outer Banks were also disabled, and none measured as high a speed as Forman had observed at Cape Lookout. At Fort Macon, the apparatus suffered electrical problems after recording eighty miles per hour, well before the peak of the storm. At Portsmouth, a maximum of ninety-seven miles per hour was recorded before the wind carried away the anemometer. Cape Hatteras's wind-measuring apparatus suffered a similar fate after registering seventy-four miles per hour. The only anemometer to hold up in the extreme conditions was the one at Kitty Hawk, recording a maximum wind speed of a hundred miles per hour.

The weather station inside the keeper's quarters at Cape Lookout survived the storm, and the anemometer was soon replaced. But a little over a year later, official weather observations at Cape Lookout came to an end. Perhaps because of its remoteness, the Signal Service decided to close the station. Just over a year later, on December 31, 1880, Private T.J. Kenan, who took over Forman's position as observer in charge of the station, collected data here for the last time. Private Kenan and his meteorological instruments were transferred to nearby Fort Macon on the Bogue Banks, where a new observatory was officially put into operation

THE GREAT HURRICANES OF NORTH CAROLINA

on January 3, 1881. Private Kenan's new post overlooked Beaufort Inlet, which was always active with vessels visiting the busy ports of Beaufort and Morehead City.

The Great Beaufort Hurricane continued moving to the northeast and returned to the Atlantic Ocean off the coast of Virginia. As it passed by, the destructive force of the storm was felt at Norfolk, where a writer for the local paper observed the progress of the hurricane:

> *At 10 o'clock the wind had gathered such strength that it was dangerous to appear on the streets, while the rain fell in such torrents that it was most disagreeable to do so. For hours the hurricane increased. Its ravages were plain and the whole city was thrown into an excitement not easily described. The rain inundated wharves, streets and the lower floors of a number of buildings. About 11 o'clock the storm had reached its height, and dealt destruction at every hand.*

The storm raced along on its northeasterly trek, passing along the coast of New England and hitting Nova Scotia on the nineteenth. On the twentieth, the hurricane raced across Newfoundland and back out to sea, where it soon lost its tropical characteristics over the cold waters of the North Atlantic. This ferocious storm left its mark on North Carolina and remains the most powerful hurricane to menace the Old North State.

The San Ciriaco
Hurricane of 1899

One of the most remarkable storms to ever hit the North Carolina coast was the San Ciriaco Hurricane, which cut a swath of destruction from the West Indies to the coast of France in the late summer of 1899. This powerful hurricane, with maximum winds in excess of 140 miles per hour, was responsible for many deaths and much destruction. The storm has the distinction of being the eighth most deadly storm in the annals of Atlantic coast hurricanes.

This hurricane made landfall on the island of Puerto Rico on Saint Ciriaco's Day, August 8, 1899, hence the name. The intense storm was one of the worst natural disasters to strike the island, causing millions of dollars worth of damage. Thousands of people in the Caribbean perished as a result of this killer storm before it moved northwest into the Bahamas and took aim at the coast of North Carolina.

The earliest recorded encounter with this storm came on August 3, 1899, when the British steamship *Grangense* passed

The Great Hurricanes of North Carolina

THE SAN CIRIACO HURRICANE OF 1899

After being driven ashore by the San Ciriaco Hurricane of 1899, the Diamond Shoals lightship (*LV-69*) was repaired and soon returned to duty. *Photo courtesy National Oceanic and Atmospheric Administration.*

Opposite above: Surfman Rasmus Midgett is shown here sitting atop the remains of the *Priscilla*, which wrecked just north of Cape Hatteras, along the Outer Banks, on the evening of August 17, 1899, during the San Ciriaco Hurricane. Midgett received the Gold Lifesaving Medal of Honor for his feat of singlehandedly rescuing ten people from the stricken ship. *Photo courtesy North Carolina Division of Archives and History.*

Opposite below: In the predawn darkness of August 18, 1899, the Diamond Shoals lightship (*LV-69*) was driven ashore by the pounding seas during the San Ciriaco Hurricane. Captain H.W. Styron and surfmen from the nearby Creed's Hill Lifesaving Station rescued all on board, and no lives were lost from the lightship. *Photo courtesy North Carolina Division of Archives and History.*

THE GREAT HURRICANES OF NORTH CAROLINA

One of the numerous ships driven ashore by the powerful San Ciriaco Hurricane in August of 1899. *Photo courtesy North Carolina Division of Archives and History.*

This Weather Bureau chart shows the progress of the San Ciriaco Hurricane through the Caribbean, across Puerto Rico and the Bahamas to a position off the Florida coast before taking aim at North Carolina.

The San Ciriaco Hurricane of 1899

Lifesavers from the Big Kinnakeet Lifesaving Station rescued several mariners from the raging storm winds and pounding surf when the San Ciriaco Hurricane stranded the *Florence Randall* near their station on the Outer Banks in August of 1899. *Photo courtesy North Carolina Division of Archives and History.*

Crewmen from the Little Kinnakeet Lifesaving Station kept busy rescuing stranded mariners during the San Ciriaco Hurricane of 1899. *Photo courtesy North Carolina Division of Archives and History.*

THE GREAT HURRICANES OF NORTH CAROLINA

Two families found refuge inside the Portsmouth Lifesaving Station from the rising storm surge that inundated much of their island during the San Ciriaco Hurricane of 1899. *Photo courtesy North Carolina Division of Archives and History.*

through it 1,880 miles east of Guadeloupe. At noon that day, located at latitude 11° 51´ north and longitude 35° 12´ west, Captain Spedding noted in his log that the weather began to change for the worse: "Clouds increased, and by 4 p.m. the wind was blowing out of the north-northwest, with force increased to fresh gale, accompanied by heavy rain." An hour later, the ship's barometer reached its lowest reading of 29.38 inches as the winds calmed and the rain ended temporarily.

The San Ciriaco Hurricane of 1899

Clearly the ship was in the eye of the storm, but instead of being tossed about at random on rough, agitated seas, the *Grangense* was buffeted by heavy seas coming from the northeast. The seas "caused the ship to pitch heavily and made it necessary to let her head off to the east in order to make headway, the ship being very light," recalled the captain.

The storm was over by 10:00 p.m., and the sky began to clear for good. Captain Spedding continued on his voyage, observing that in his many years of travel between Europe and the Amazon, this was the farthest east that he had ever encountered such a storm.

On the afternoon of August 7, 1899, the hurricane passed directly over the islands of Guadeloupe and Montserrat. The latter, located farther to the south and east, was the first to be lashed by the storm. "All the churches, estates, and villages, were destroyed, and nearly 100 persons drowned," a correspondent for the *New York Times* observed. "In addition, many were injured and rendered homeless, and terrible distress exists amongst the sufferers."

On the island of Guadeloupe, the hurricane made landfall near Point-à-Pitre at approximately 11:00 a.m. and lasted until about 4:30 p.m. The damage was extensive and widespread along the coast as well as in the interior of the island. A correspondent noted:

> *Many houses had their roofs blown off and were flooded, and some of them were demolished, but no fatalities were*

> reported. *Twenty three flat boats and fishing boats were sunk in the harbor, in addition to schooners, two small steamboats, and a steamship,* Hirondale, *which were wrecked at other places. The* Aleyou *had her stern damaged. The French cruiser* Cecille, *which was in the harbor, did not suffer at all.*

Other small islands nearby also suffered from this (as of yet) nameless storm. Antigua endured severe damage, but there was no report of loss of life. On Nevis, the destruction was general, and at least twenty-one people were known to have died as a result of the storm.

Over on the island of St. Kitts, there had been no signs of an approaching hurricane, and the weather was particularly warm and clear throughout the day on August 6, 1899. "The sea was wonderfully clear, so much so that one could see very distinctly the stones on the bottom," recalled W.H. Alexander, the official weather observer for the U.S. Weather Bureau at Basseterre, a town located on the coast of this small island. The temperature that day reached eighty-eight degrees Fahrenheit, "the warmest of the season thus far," wrote Alexander. As the day wore on, the winds freshened and the sky began to be overcast, but there were still none of the usual signs of an approaching storm. "The sunset was marked by saffron skies, nor did the barometer, up to this time, show the slightest tendency to depart from its normal condition."

The San Ciriaco Hurricane of 1899

But there was indeed a hurricane bearing down on this location. The hurricane passed approximately seventy-five miles south of the island of St. Kitts. The highest sustained wind speed recorded by Alexander at Basseterre was 120 miles per hour. The rains, however, were not severe, as just over an inch of rain fell there. Alexander had received notice from the U.S. Weather Bureau in Washington via telegraph that a storm was approaching and to therefore raise the hurricane warning flag. He was able to spread the word across the island in such an effective manner that no one was caught off guard. "That the entire Island of St. Kitts was warned in good time is shown by the fact that not a death resulted from the hurricane," he wrote. Alexander had been unable to warn the inhabitants of nearby Nevis and Antigua.

With its continuing west–northwest track, the hurricane skirted just south of the Virgin Islands. The island that suffered most in this group was St. Croix. One witness noted: "Nearly every estate has been wrecked, the large buildings in the towns have been unroofed, stock has been killed, and a minimum of eleven deaths have occurred among the laborers."

As the storm churned steadily onward through the night of August 7, 1899, the hurricane took aim at the coast of Puerto Rico. This island was trying to recover from the turmoil following the end of the Spanish-American War, and many communities were ill prepared to cope with a natural disaster. Ready or not, on August 8, 1899—Saint Ciriaco's Day—this killer hurricane roared ashore on the southeast coast and

traversed the island. In its wake, the storm left behind damage estimated at $20 million, and a death toll in excess of three thousand people. Hardest hit was the coastal city of Ponce, where five hundred people were killed, most as the result of the flooding unleashed by the storm's torrential rains.

News traveled slowly in those days, so most people who lived in the remote reaches of eastern North Carolina were ignorant to the plight of the people in the Caribbean. Most were probably not that familiar with Saint Ciriaco or the fact that a powerful hurricane had been named in his honor. For most of the inhabitants of the Carolina coast, the hurricane was known simply as the August storm. "The oldest people on Ocracoke said that the 'August storm' was the worst one within the memory of living men," recalled Redding G. Thompson, a witness to the storm's fury at Ocracoke.

> *Certainly there has not been one since that matched it for high winds, high water and destruction. I, myself, have been on or near the coast during every hurricane since then. "Hazel," and "Dianne" and "Ione," and all the "named" storms since then have merely been young women, with billowing shirts on a windy day when compared to the "August Storm" of 1899.*

From Cape Lookout north along the Outer Banks, destruction from the San Ciriaco Hurricane was widespread. On the Shackleford Banks, near where the hurricane first made landfall,

The San Ciriaco Hurricane of 1899

waves rolled over the sandy barrier island, inundating the entire island and even washing away some prominent landmarks, dealing the local villages a lethal blow. After riding out the latest in a procession of fierce storms that had taken aim at their barrier island, many of the inhabitants decided to move to other locales that were not as susceptible to the elements. Some moved to the Bogue Banks and others moved to Morehead City, while many moved across Back Sound to Harkers Island.

On the Core Banks, the rising waters from the storm surge drove the men stationed at the Core Banks Lifesaving Station into the second floor of their dwelling as floodwaters filled the first floor. At Portsmouth, it was later reported that not a single structure in the town escaped damage. All of the livestock in town was drowned.

Captain David Styron described the damage at Portsmouth:

> *My brother was among the biggest sufferers. He was among the best well off on the banks and says he is not worth 15 cents now. His store and goods are gone, his stock all gone, 25 ponies and 20 head of cattle and sheep all drowned. I counted fifty-seven sail boats when I left, looking for the bodies of the drowned. I heard that when the four Fulcher brothers were discovered, it was found that they had lashed their bodies together with ropes in their skiff and so remained when death overtook them. I have followed the sea for 13 years and nothing like*

that has been my experience before. I never could tell the half. It was pitiful to have children clinging to your knees begging to be saved and it seemed as if I never saw so many of them at once.

On the afternoon of August 18, 1899, Keeper F.G. Terrell and Surfman William Willis, two lifesavers from the Portsmouth Lifesaving Station, spotted a distress sign from the *Fred Walton*, which was wrecked upon Hog Island Shoal near Ocracoke Inlet. As they rowed their surfboat out to the distressed boat, they passed another vessel, the *Lydia A. Willis*, wrecked upon Dry Shoal Point. There were no signs of life aboard, so they continued to the *Fred Walton*, where they rescued Captain W.D. Gaskill and his wife. After depositing these folks on shore at Ocracoke, they noticed signs of life on the vessel they had passed earlier and rowed out to investigate. There they found several men in tired and battered condition. These were four of the six people who had ridden out the storm in the rigging of the *Lydia A. Willis*, as the deck of the vessel was submerged under the water while the hurricane raged at full force. Keeper Terrell later reported:

They wanted to be carried off to Ocracoke ware there friends was [sic]. *One was very bad off. We used bottles of hot water and heated bricks to his limbs and soles of his feet. We stade* [sic] *with them all night and brought them out all right. Put them aboard the steamer*

The San Ciriaco Hurricane of 1899

> Ocracoke *Sunday morning which they took for thear* [sic] *homes, Washington, N.C.*

Across the inlet, thirty houses were destroyed on Ocracoke, along with the school and two churches. One witness wrote: "Not since the awful storm of 1846 has Ocracoke been witness to such scenes. The whole island is a complete wreck." A few miles up the beach, the waters of the storm surge cut a new inlet across the sandy island. This breach did not remain open for long.

Redding Thompson was a young boy at the time and fled with his mother and brother from their waterfront cottage on the sound side of Ocracoke to a neighbor's house. The water inundated the family's cottage up to the second floor but only made it into the first floor of Captain Bragg's, who had taken the precaution of cutting holes in his floor and "scuttling" his house, a common practice employed by residents along the coast in those days to prevent their houses from floating away on the rising floodwaters of the surge.

Thompson recalled watching three sailing vessels anchored in the channel near his family's summer home as they dashed about wildly in the turbulent waters of Pamlico Sound. One unmanned schooner was carried away. On another schooner were two men who had remained on board in hopes of riding out the storm. As conditions deteriorated, they made frantic pleas for rescue, but no one was able to come to their aid. The storm-battered ship eventually broke free from its

anchor and washed out to sea. The doomed schooner, and its unfortunate occupants, was never heard from again.

Another young man who witnessed the fury of the San Ciriaco Hurricane at Ocracoke was Big Ike O'Neal. He later reminisced with Bill Sharpe of *The State* magazine about his experiences during this terrible storm.

> *The wind was rising and the water came running through the house like a mill-race. In the front room the children were a-cryin', and the women were a-screamin', and the men were a-shoutin'. I went back to the kitchen to chop a hole in the floor, so the water could level off, and maybe not float the house away. When I got the hole chopped, a big gush of water came through, and guess what? A big white duck, caught under the house, whizzed through, fluttering and a-quacking and she didn't stop until she hit the ceiling. It near scared me to death.*

This was not O'Neal's only unusual wildlife encounter during the San Ciriaco Hurricane. He also reported seeing dolphins swimming through the flooded streets of Ocracoke.

The lone occupant of the third vessel mentioned by Thompson had a wild ride on this schooner as the hurricane winds battered his vessel. According to Thompson:

> *His sloop, when it passed Springers Point, cut across the beach, which was covered by many feet of water, and hit*

The San Ciriaco Hurricane of 1899

an isolated sand dune, which we knew at that time as a "hammock." When the sloop hit this "hammock" the boy decided to get off the sloop and onto the "hammock," although the "hammock" was submerged and he had to stand in waist deep water. The sloop soon freed itself and went on out to sea and was never seen again. The boy stayed on the hammock until the storm abated, and the water went out, and then walked back up to Ocracoke village. Of course, everyone had given him up for lost, and were amazed to see him.

Just up the banks on Hatteras Island, S.L. Dosher was the weather observer on duty for the U.S. Weather Bureau when the San Ciriaco Hurricane came through. The lowest atmospheric pressure he reported from the storm was 28.62 inches. He noted that the highest winds recorded were between 120 and 140 miles per hour, which occurred at 1:00 p.m. on August 17. Shortly after making this observation, the anemometer blew away, and there were therefore no official measurements of the extreme wind velocity when the hurricane was blowing at its peak intensity between 3:00 and 7:00 p.m. on Hatteras. Had the wind gauge not blown away, it is conceivable that wind speeds equaling those recorded twenty years earlier at Cape Lookout during the Great Beaufort Hurricane would have been measured.

A more accurate account of the storm's intensity at Hatteras may have been chronicled by Lieutenant C.E.

Johnson of the U.S. Revenue Cutter Service. He had been dispatched from Washington to gather information about the damage wrought by the storm along the Outer Banks. "The hurricane attained frightful velocity in the vicinity of Cape Hatteras," said Johnson.

> *No one will probably ever know the real intensity of the storm. At the Hatteras weather bureau station the anemometer blew down while registering a wind velocity of 120 mile an hour, and one velocity of 130 miles an hour, and one squall blew for a fraction of a minute at the rate of 160 miles per hour. The low barometer reading was 28.55, but the hands oscillated below 27. It was evident from the state of the barometer that the center of the hurricane passed a little to the east and south of Cape Hatteras.*

Dosher provides a great eyewitness account of the effects of this storm as it passed over Hatteras Island:

> *This hurricane was the most severe in the history of Hatteras. The scene on the 17th was wild and terrific. By 8 a.m. the entire island was covered by water from the Sound, and by 11 a.m. all the land was covered to a depth of from 4 to 10 feet. This tide swept over the island at a fearful rate carrying everything movable before it. There were not more than four houses on the island in*

which the tide did not rise to a depth of 1 to 4 feet, at least half the people had to abandon their homes and seek safety with those who were fortunate enough to live on higher grounds. The frightened people were crowded 40 to 50 to a house. All this day the gale, the tide, and the sea continued with unabated fury. During the lull in the evening the tide ran off with great swiftness, causing a fall in the water of several feet in less than half an hour. Domestic stock was drowned, and it is believed that the property loss to Hatteras alone will amount to $15,000 or $20,000. The fishing industry has, for a time, been swept out of existence, and of the 13 fish-packing houses, which were situated on the waterfront, 10 with all their equipments and contents were lost. A great proportion of the houses on the island were badly damaged and many families are without homes. All bridges are swept away and roadways are piled high with wreckage. All telegraph and telephone lines are down.

Ships were damaged and destroyed all along the Atlantic seaboard from Florida to Massachusetts. For several weeks after the storm, ships came into ports all along the East Coast with reports of encounters with this powerful tempest. Some bore survivors of ill-fated vessels who were lucky just to be alive. Others bore reports of abandoned ships that had lost their rigging and their crew and were floating aimlessly on the high seas.

One of the most tragic episodes of the hurricane was the ordeal of the men aboard the Norwegian bark *Drot*, which encountered the hurricane well out in the Atlantic between Cape Hatteras and Florida. The crew bravely fought the howling winds and raging seas, but eventually nature prevailed. A monstrous wave struck the ship, washing the captain and seven of his crewmen overboard. Despite their best efforts, the ship was being beaten to pieces by the waves.

The men finally decided to save themselves before the ship was totally lost. A raft was cobbled together with planks from the *Drot*'s deck, upon which the mate and the seven remaining seamen took to the sea. In the rough seas and raging storm, their makeshift raft broke into two pieces. On one part rode the mate and one of the men. Being overcome with fear, the mate jumped overboard and committed suicide. The remaining man did not give up so easily and continued riding out the storm. His confidence paid off, as he was picked up off the Carolina coast by the *Titania*, a German steamship, and subsequently landed in Philadelphia.

The six men on the other portion of the raft had their own particular hell to deal with. One man lost his mind and jumped into the raging sea where he drowned. As time passed and the storm continued unabated, two of his companions followed his example, taking their own lives by plunging into the sea.

The three remaining men were Maurice Anderson, Goodmund Thomason and a German whose name was not

The San Ciriaco Hurricane of 1899

recorded. They drifted on the storm-tossed waters of the Atlantic, with neither water to quench their thirst nor food to slake their hunger. Realizing that they would soon die of thirst or starvation, the three men agreed to draw lots—the loser would be killed and consumed by the other two. The German lost the wager and was promptly dispatched by Thomason and Anderson, who drank the blood from his veins.

This act of murder and cannibalism was too much for Anderson's conscience to deal with. The thought of the brutal deed wreaked havoc on his mind, and he soon went insane. In a fit of madness, he attacked Thomason, biting huge chunks of flesh from his chest and face before he could be subdued.

On August 31, 1899, after two weeks of terror on the high seas, the raft containing the pitiful men was picked up by the British steamer *Woodruff* drifting 250 miles off the South Carolina coast. They were taken into port at Charleston, where they were given to local authorities. Word of their story soon leaked out, and press reports noted: "Anderson is a raving maniac, and his companion is shockingly mutilated from bites of the crazed man." Both men were hospitalized and then turned over to the Norwegian consul in Charleston, who took them back to Norway to answer for their crimes.

Wrecked ships littered the coastline of the Atlantic seaboard from Florida north to New England. In North Carolina alone, over fifty ships were wrecked along the coast between Cape Fear and Currituck. These wrecks were distributed on the beaches facing the ocean, as well as in the

sounds where the smaller vessels that plied these local waters fared badly from the effects of the storm.

One of the wrecks on the sound side was the ship belonging to Captain Thomas Gard, who had left Elizabeth City on August 12, 1899, making his normal run with supplies for the U.S. Lifesaving Stations along the Outer Banks. Sensing an impending storm, Captain Gard anchored his vessel on August 17 in what he thought was the protected cove at Durrant's Bay, where he hoped to ride out the storm in relative safety. Later that day, as winds increased and the storm surge rose, waves began breaking over the bow of his boat. At 3:00 p.m., he slipped his anchor and hoped to let his boat ride out the storm as best it could. Shortly thereafter, waves broke off his mainmast. By 4:00 p.m., as the tide began to fall, the boat came to rest high and dry in the live oaks. When asked about his ordeal afterward, he stated that he had never experienced a storm as strong as the San Ciriaco Hurricane "and hope[d] to be on terra firma should another of its kind come this way."

One of the most tragic episodes that played out over Pamlico Sound as the San Ciriaco Hurricane raged involved a group of fishermen from the Down East section of Carteret County who were killed in the storm. They had ridden out the initial onslaught of the storm in their camp on Swan Island, near the mouth of the Neuse River, but they made a terrible decision to leave their place of refuge while the eye of the slow-moving hurricane was passing overhead. Perhaps they

thought the storm was over, as the weather had turned fair and the winds were calm. But this proved to be a fatal error.

On the backside of the hurricane, the winds blew with redoubled fury. The waters of the sound, which had been backed up on the Neuse by the onshore winds on the north side of the cyclone's eye, were now being driven back out toward sea. What one witness remembered as a wall of water between ten and twelve feet high swamped their small skiffs, which were small boats only twenty feet long. The occupants of these small boats were cast overboard into the churning waters of the sound. Out of the sixteen men who camped on Swan Island, only two survived. A newspaper account stated that the two survivors had cut away the mast of their skiff, jettisoned their cargo in order to lighten their load and drifted before the winds. They watched helplessly as the other fourteen members of their party died.

Among the vessels wrecked on the beach was the Diamond Shoals Lightship *LV #69*, which broke loose from its anchorage off Diamond Shoals. Despite the captain's best efforts to keep the boat on its post, its motors were no match for the winds of this storm. With engines at full throttle, the boat was pushed relentlessly west until it finally washed ashore just west of the Creed's Hill Lifesaving Station. Crewmen from the station rescued the stranded mariners from the lightship without loss of life.

Lifesavers from the Chicamacomico Lifesaving Station rescued seven mariners from the *Minnie Bergen*, a three-

masted schooner loaded with an assorted cargo of oil, iron and coal. They fired the Lyle gun and set up a breeches buoy to the stricken vessel, which was grounded in the surf just over a mile north of the station.

One unfortunate vessel that wrecked on Hatteras Island was the *Aaron Reppard*, a three-masted schooner bound from Philadelphia to Savannah, Georgia. It was caught in the mighty tempest and driven ashore approximately two and half miles south of the Gull Shoal Lifesaving Station on August 16, 1899. Eight men were aboard the vessel, including the captain, the six crewmen and a passenger, all of whom were forced to climb into the ship's rigging to get away from the raging surf that washed over the deck of the stranded ship. Fortunately, they had wrecked just offshore of the beach where Surfman Rasmus Midgett was on patrol. Midgett spotted the ship and immediately sent for help. Surfmen from Gull Shoal, Little Kinnakeet and Chicamacomico were all on hand to render aid to the stricken vessel. After suffering many hardships and facing great dangers, these brave lifesavers managed to rescue three of the eight men from the doomed ship.

A half mile south of the *Aaron Reppard*, eighteen miles north of Cape Hatteras, another vessel washed ashore. This was the *Priscilla*, a barkentine sailing from Baltimore and bound for Rio de Janeiro. On board were Captain Benjamin Springsteen, his wife Virginia and their two sons, William— who served as first mate—and twelve-year-old Elmer. In addition to these family members, there were twelve other

The San Ciriaco Hurricane of 1899

crewmen on board. On the morning of August 18, 1899, the storm-battered vessel grounded after spending a terrifying night being pounded by waves as the helpless ship drew closer to shore. The previous evening, Mrs. Springsteen and her two sons, along with the cabin boy named Fitzhugh Lee Goldsborough, had been washed from the vessel and were killed. As the storm was driving the ship down the beach and beating it to pieces, William Springsteen was heard to yell out into the storm to Captain Springsteen, "Father, you look out for the boys. I'll save mother or go with her." As he got her from her cabin, which was quickly filling with water, up onto the deck, a massive wave struck the vessel and carried William and Virginia Springsteen overboard, where they were both killed. Meanwhile, Captain Springsteen was holding onto his youngest son for safety, but tragically the boy was lost. The captain himself managed to survive the ordeal but sustained several grievous wounds.

The entire complement of the *Priscilla* might have shared a similar fate, but fortunately they were spied by one of the men from the Gull Shoal Lifesaving Station. As the ship was grounded in the raging surf, being pounded to pieces, Surfman Rasmus Midgett of the nearby lifesaving station happened upon the wreck. Midgett singlehandedly saved ten people from the *Priscilla*, a feat that earned him the Gold Lifesaving Medal.

According to the National Hurricane Center's publication, "The Deadliest Atlantic Cyclones, 1492–1996," the official

death toll from this storm was 3,433 people from the Caribbean to the Carolinas. There were probably even more fatalities from ships lost at sea and individuals who perished in remote areas of the islands in the Caribbean, where the vast majority of the casualties occurred. This gives the San Ciriaco Hurricane the distinction of being the eighth most deadly tropical cyclone recorded in the Atlantic Ocean.

After making landfall in the vicinity of Cape Lookout, the slow-moving storm made a sharp right turn and passed back out to sea off the vicinity of Ocracoke. After leaving the Outer Banks, the San Ciriaco Hurricane continued to be a menacing storm for mariners in the Atlantic. The long-lived storm was tracked by the U.S. Weather Bureau across the Atlantic, past the Azores and on to France. A report in the October 1900 edition of the *Monthly Weather Review* noted:

> *On September 9 it was central off the coast of Provence, France, gales prevailed in this region until September 12, on which date the storm apparently had united with an area of low barometer covering southeastern Europe.*

In all, this remarkable storm existed for thirty-six days, making it the longest-lived tropical cyclone ever observed in the Atlantic Basin. Along a dangerous stretch of coast renowned for its turbulent weather, few storms have ever equaled the San Ciriaco Hurricane.

The Great Atlantic Hurricane of 1944

One of the most powerful hurricanes of the twentieth century roared ashore along the Outer Banks during the fall of 1944. The strong winds and high storm surge left a trail of destruction from Portsmouth to Currituck. Tragically, hundreds of servicemen lost their lives as the storm went on its rampage out of the warm waters of the tropics north to the New England coast. Approximately fifty-two people were killed along the Outer Banks, either in ships just off the coast or on shore along the sandy barrier islands.

Ironically, most North Carolinians were unaware that this potent storm had left behind such a trail of destruction. Louis Effrat, a writer for the *New York Times*, summed the matter up in his outdoors column when he wrote:

> *From Raleigh, N.C., comes word that a week after the hurricane, which many mainlanders thought had missed North Carolina, it develops that the Outer Banks*

The Great Hurricanes of North Carolina

The Great Atlantic Hurricane of 1944

The USCGC *Jackson* was one of two Coast Guard cutters that sank in the heavy seas off the Outer Banks during the Great Atlantic Hurricane of 1944. Twenty-one men from the *Jackson* perished in the ordeal, including its captain, Lieutenant N.O. Call. *Photo courtesy U.S. Coast Guard.*

Opposite above: The mail boat *Aleta* and another boat were left stranded on high ground after the waters receded from Ocracoke Island following the passage of the Great Atlantic Hurricane in September of 1944. *Photo courtesy R.S. Spencer Jr., Hyde County Historical Society.*

Opposite below: The Ocracoke Lighthouse has weathered many hurricanes since it was first put into service in 1823. Waters from storm surges have inundated other parts of the island, but the lighthouse has remained dry. Only the floodwaters from the Great Atlantic Hurricane of 1944 have come close, rising to the level of the adjacent keeper's quarters. *Photo courtesy U.S. Coast Guard.*

The Great Hurricanes of North Carolina

THE GREAT ATLANTIC HURRICANE OF 1944

Several boats such as these at Hatteras were damaged or destroyed by the raging surf and fierce winds of the Great Atlantic Hurricane of 1944. *Courtesy of* Our State *magazine archives.*

Opposite above: Shown here in port at some point prior to World War II, the USCGC *Bedloe* was one of two Coast Guard vessels that sank off Oregon Inlet during the Great Atlantic Hurricane of 1944. Twenty-six crewmen died on this ill-fated vessel as a result of the hurricane. *Photo courtesy U.S. Coast Guard.*

Opposite below: The floodwaters rose to unprecedented levels at Ocracoke during the Great Atlantic Hurricane of 1944. The flooding brought back memories of the dolphins that were seen swimming through town in the floodwaters accompanying the San Ciriaco Hurricane of 1899. *Courtesy of* Our State *magazine archives.*

THE GREAT HURRICANES OF NORTH CAROLINA

The eight men shown in this photo are survivors from the *Bedloe*, one of the two U.S. Coast Guard cutters that sank off the Outer Banks during the height of the Great Atlantic Hurricane of 1944. The picture was taken on September 14, 1944, in the naval hospital in Norfolk, Virginia, where the injured and dehydrated men were taken after their perilous ordeal. The Coast Guardsmen in this photo were identified as Seaman First Class Jerry VanDerPuy, Soundman Third Class John Kissinger, Seaman First Class Robert Greeno, Seaman First Class Robert Hearst, Soundman Second Class Joseph Martzen, Radioman Third Class Michael J. Cusono, Chief Radioman Pearcy C. Poole and Coxswain Joseph Ondrovik. *U.S. Coast Guard Photo*.

THE GREAT ATLANTIC HURRICANE OF 1944

suffered, the worst storm in the history of this stormy country. Villages well known to fishermen everywhere were all but leveled and the section still is isolated, without customary communications.

No one knows exactly where this hurricane originated. It was first observed to the northeast of the Windward Islands, but the true extent of the storm was unknown. It may have been a Cape Verde hurricane, but so far that is not known for sure. The storm followed a track that carried it to the north of the Greater Antilles and took aim at the Bahamas. Pioneers in the early days of hurricane reconnaissance flights flew military aircraft from both the army and navy into the storm and established its position north of Puerto Rico. The reports they brought back convinced the forecasters at the U.S. Weather Bureau Office in Miami that this was a massive and violent storm with winds in the neighborhood of 140 miles per hour, and they thus named the storm the Great Atlantic Hurricane.

The destroyer USS *Warrington* sailed out of the Norfolk Naval Yard on September 10, 1944, headed for the Caribbean Sea. It was acting as an escort for another vessel, the USS *Hyades*, protecting that ship from possible attack from any German U-boats that were lurking about the area. Though dangerous work, these escort patrols had become somewhat routine by this late stage of the war. As they were soon to discover, Mother Nature was more of a menace to their cruise than was the German navy.

On the evening of September 12, 1944, the *Warrington* and the *Hyades* ran right smack into the middle of a ferocious hurricane that was brewing in the Atlantic. They were approximately four hundred miles southeast of Cape Lookout, and the heavy seas battered the ships, which had inadvertently navigated near the eye of the powerful storm instead of passing off to the north and east of it as they had originally planned.

Battered by heavy seas that included waves estimated to have reached as high as seventy feet, the *Warrington* sank after capsizing in the hurricane shortly after midnight on September 13, 1944. A total of 247 sailors and officers out of a complement of 321 perished in the storm-tossed waters of the Atlantic.

The Great Atlantic Hurricane of 1944 was not finished claiming sailors for Neptune. The storm raced ahead north–northwest at twenty-five miles per hour, headed for the North Carolina Outer Banks.

The *Warrington* was not the only military ship claimed by this monstrous hurricane. On September 12, 1944, the *George Ade*, a Liberty ship that was loaded with 850 tons of cargo, was en route from Key West to New York when it was hit by a torpedo. The weapon had been launched by a German U-boat, the *U-518*, which found the unescorted ship while patrolling approximately 125 miles off the North Carolina coast.

The Liberty ship was severely damaged in the attack but did not sink. Distress calls soon brought help from the U.S. Navy.

The Great Atlantic Hurricane of 1944

The USS *Escape* arrived on the scene, took the damaged vessel in tow and headed north for the naval yards at Norfolk. Two Coast Guard cutters, the *Jackson* and the *Bedloe*, also arrived on the scene to escort the stricken vessel back to port.

On Thursday morning, September 14, 1944, the four vessels were overtaken by the swift-moving Great Atlantic Hurricane. Monstrous seas battered the ships, and both cutters went down approximately fifteen miles off the Outer Banks, near Oregon Inlet and the Bodie Island Lighthouse. Twenty-six of the thirty-eight men aboard the *Bedloe* perished, while twenty-five of the forty-one-man crew from the *Jackson* were lost.

The official U.S. Coast Guard account stated:

> *Struck four times by towering waves, the* Bedloe *tossed like a matchstick in the ocean before going down. All 38 officers and crew men safely abandoned the ship and at least 30 were able to hold on to liferafts. However, the strain of fighting the hurricane aboard, plus the ordeal of hanging to liferafts for 51 hours, proved too much for most of the men and only 12 were able to hang on until rescued.*

The same chronicle also described the loss of the *Jackson*:

> *Borne to the top of a huge swell, the* Jackson *was struck by two swells and rolled over until the mast dipped water.*

THE GREAT HURRICANES OF NORTH CAROLINA

> *As the swells subsided, the ship righted and was hit by another high sea and turned on her side a second time. Struggling out of that, the vessel was carried high by a third sea. It seemed then, survivors said, that she clung in mid-air for seconds; then the wind seized her, turned her on her side and completely over. She disappeared under a huge wave.*

Ironically, the ships the two cutters were sent to protect survived the storm and made their way north to Chesapeake Bay. Two months after being towed in, the *George Ade* returned to service hauling cargo for the war effort. But it would be nearly half a century before anyone would see either the *Jackson* or the *Bedloe* again.

The Great Atlantic Hurricane weakened some as it sped north on September 13. Earlier that evening, the storm's intensity peaked with sustained winds of 140 miles per hour and a barometric pressure of 26.85 inches. When the storm made landfall at Hatteras, the winds were officially recorded at 90 miles per hour average sustained over a five-minute interval, with a peak gust of 110 miles per hour. This was only an estimate, as the instruments measuring the wind's speed and direction were disabled at some point prior to the peak of the storm. This estimate appears to be somewhat low. Unfortunately, the 90 miles per hour reading has led some to dismiss this storm as a weak Category One hurricane when it passed through North Carolina,

The Great Atlantic Hurricane of 1944

and thus of little or no consequence in the annals of the state's hurricane history. But an evaluation of other factors shows that the storm was much stronger than has been generally reported—it was at least a strong Category Three hurricane, and one of the most intense storms to visit the Outer Banks in the twentieth century.

The storm's powerful, right front quadrant, the part of the hurricane where the highest winds are normally encountered, remained offshore as the eye of the storm passed Hatteras. The eye of the storm came ashore over Hatteras Island, passing over Avon and Rodanthe, reaching as far inland as Roanoke Island before curving back out to sea near Nags Head.

The Reverend F.B. Dinwiddie recorded several meteorological observations of this hurricane as it passed along the northern Outer Banks. He was at Nags Head when the storm began but sought a safer vantage point several miles inland on Roanoke Island in the community of Wanchese as the worst of the storm blew by. At Wanchese, the period of calm associated with the passage of the eye of the storm lasted for approximately thirty minutes. He estimated that the center of the eye was east of his position, putting it potentially just offshore. Clearly the period of calm was longer at Avon, which was much closer to the center of the storm, with the calm lasting for an hour and thirty minutes. The Reverend Dinwiddie commented about the winds:

The Great Hurricanes of North Carolina

> *We should think our 5 minute maximum between 12:50 and 1:00 p.m. was not less than 90 miles an hour, for the wind during the climactic period seemed sustained at the extreme level with comparatively little fluctuations and no respite, until the amazingly sudden relief came at 1:10 p.m., when the 70 mile wind seemed like a breeze in contrast.*

Farther up the coast at Cape Henry, Virginia, which was several miles farther from the eye of the storm than Hatteras, weather observers recorded a low barometric pressure of 27.75 inches, and five-minute sustained winds of 85 miles per hour, with gusts in excess of 150 miles per hour. The Weather Bureau's official report, written by H.C. Sumner, noted:

> *The highest wind velocity recorded by instrument was an extreme velocity of 134 miles per hour, observed at approximately 12:20 p.m. on September 14, at Cape Henry, Va. Maximum wind velocities equaled or exceeded all previous records at Hatteras, Cape Henry, Atlantic City, New York and Block Island.*

One would expect the wind speeds to have been much higher and the pressure to have been much lower in the eyewall of the hurricane at Hatteras than was recorded at a place several miles removed from the center of the storm,

The Great Atlantic Hurricane of 1944

such as Cape Henry. But mysteriously, the official report of conditions at Hatteras showed just the opposite—at least as far as wind is concerned.

This leaves us with some interesting questions and unsolved mysteries. When stating that the wind speeds from this storm set records at Hatteras, it is possible that Sumner was not familiar with reports from the San Ciriaco Hurricane, in which wind speeds well in excess of those officially reported in 1944 were measured back in 1899. There could have been some sort of malfunction with his weather instruments, or he could have simply made a mistake when recording the wind speed at the height of the storm at Hatteras in 1944. There is also a possibility that, just as Sumner stated, the "maximum wind velocity equaled or exceeded all previous records at Hatteras," but the official wind speed report was not accurately reported to the public due to the wartime security measures then in place. It is known that information about the effects of the hurricane was censored by the federal government, which was mindful of the possibility of German U-boat commanders using such information as a pretext to increase their attacks on shipping. Even the report of the American Red Cross's initial survey of the extent of damage along the Outer Banks was classified.

Unfortunately, we will probably never know just how powerful the winds were at Hatteras when the eyewall of the Great Atlantic Hurricane struck the Outer Banks.

We can, however, get some idea of just how powerful this storm was along the Outer Banks thanks to the atmospheric pressure readings Sumner reported. The lowest atmospheric pressure recorded at Hatteras during this storm occurred at 8:20 a.m. The reading was 947.2 millibars, or 27.97 inches. Based on the Saffir-Simpson scale, this atmospheric pressure reading indicates that this hurricane was a strong Category Three storm when it passed near Hatteras. Bear in mind that the center of the storm, where the pressure is lowest, did not pass directly over Hatteras, and the powerful, right front quadrant of the storm remained offshore. Thus, the pressure in the eye of this hurricane may have been even lower. How much lower will never be known, but it is quite possible that it fell below the 944 millibar threshold to make this a Category Four storm.

The effects of this powerful storm were felt all along the North Carolina coast, from the Core Banks north to Currituck, and were especially evident in the northeastern part of the state. Witnesses who lived at Portsmouth claimed that the rising waters of the storm surge nearly inundated the whole island. Across the inlet at Ocracoke, the storm surge was also among the highest ever experienced in that island's long history of dealing with hurricanes.

On the walls of an old cottage in Ocracoke were found some interesting observations on local weather conditions for various storms, including this one. It is noted that the winds were rising throughout the predawn hours, and by 7:00 a.m.

The Great Atlantic Hurricane of 1944

the winds had reached a speed of eighty-six miles per hour. The note continues:

> *Anemometer on water tower at Naval Base carried away. Later wind estimated at 100 knots. Barometer 28.40.*
>
> *7:30 a.m. Winds shift to northwest. 14 foot tides. Island completely under water. Most fishing boats blown far ashore, causing considerable damage to boats and docks. Mailboat tossed ashore close to coffee shop (Island Inn). Six houses completely demolished.*

By 9:25 a.m., the wind began to slacken, and conditions were calm by 12:30 p.m. The unknown chronicler summed up his observations of the storm: "Far worst storm ever to strike island. No lives lost."

Captain Joe Burrus was the lighthouse keeper at Ocracoke when the Great Atlantic Hurricane hit. According to an account of his life while keeper at Ocracoke:

> *The Burrus family lived through three hurricanes at Ocracoke Lighthouse—1933, 1938 and 1944, and of these, the last was by far the worst. The water flooded the entire island, rising in many homes as high as twenty-five to thirty inches. At the keeper's house—located on one of the island's highest spots—it was seven inches deep—and for the first remembered time it lapped against the doorstep of the lighthouse proper.*

THE GREAT HURRICANES OF NORTH CAROLINA

Shortly after the storm, Bill Sharpe of *The State* magazine visited Ocracoke and interviewed several individuals about the effects of the storm. All agreed that the floodwaters caused by the storm surge at Ocracoke were unprecedented. Sharpe wrote:

> *Big Ike O'Neal, of Ocracoke, who is "might-as-well-say-80" since he's 79, never before saw the tide rise as high as it did in September. He opened both front and back doors and let it come right through, and perhaps thereby saved his home. A Coast Guardsman at the Ocracoke Lighthouse was talking to Portsmouth Coast Guard Station across the inlet, and reported there was no tide in evidence. "And then, whilst I was talking, I looked out across the lighthouse lawn, and there she was a'comin', and before I hung up the receiver, she was around me feet."*

Captain Willie Wescott, a veteran of the campaigns against Field Marshall Irwin Rommel in the earlier years of the war, was serving as the keeper of Gull Shoal Coast Guard Station when the Great Atlantic Hurricane struck the Outer Banks. While riding out the storm in the station, he had a wild ride down the beach as the wooden building was taken away in the storm surge and floated a quarter of a mile before it came to rest in the edge of the raging surf. "Africa was a picnic side of this," he declared soon after the

The Great Atlantic Hurricane of 1944

storm when comparing his hurricane experiences with his previous military adventures. "I was just plain scared." The Gull Shoal Station was damaged beyond repair, and never returned to service.

At Avon, O.G. Gray took advantage of the calm period to leave his house and run to his store to secure his cash box before the storm started howling again. While inside his store, the surge came and the building floated off in the rising waters. Before he could be whisked away to a terrible fate, he jumped for safety into a nearby tree, where he spent the next three hours watching most of the other houses in Avon float by. He must have been especially alarmed to see his own house go floating by, with his family still inside. Great must have been his relief to see the house come to rest less than a mile away without being swept out to sea with its occupants.

J.A. Burglass was one of several individuals who found refuge from the storm inside the Kill Devil Hill Coast Guard Station, where Captain Midgett and his men were hard at work rescuing people from the rising floodwaters of the storm surge. Burglass noted that the winds were exceptionally powerful, and that when the wind registered 90 miles per hour sustained on the wind gauge at the station, crewmen were able to walk upright. However, during the peak of the storm when the wind was blowing much harder, he noted that "it was necessary for them to crawl on their bellies when they went out shortly before noon." The wind

was so intense that the wind-driven sand scoured the paint off his automobile. Midgett later claimed that this was the hardest he had ever seen the wind blow, and he estimated that it was blowing at 125 miles per hour.

In Elizabeth City, the wind blew so hard that witnesses reported seeing a man being picked up from the sidewalk and blown completely over his automobile, depositing him in the middle of McMorrine Street. Another curiosity of the wind witnessed at Elizabeth City was not quite as spectacular as a flying man, but it was unusual nonetheless. The powerful winds on the west side of the hurricane had nearly blown the waters out of the Pasquotank River. Witnesses noted that, for several hours, the river looked liked a small creek as it was reduced to only a fraction of its normal size.

The roof of one of the hangars housing the navy's blimps at Weeksville was torn off during the height of the storm. Only one of the blimps sustained damage by falling debris. Fortunately, the rest of the fleet of blimps was able to take to the air and look for survivors of the stricken Coast Guard cutters off Oregon Inlet.

Roanoke Island was cut off from communication with the outside world. "Not in its entire history has Roanoke been utterly isolated from the outer world," observed a correspondent for the *Daily Advance*. "It was last cut off in February 1940 when the sounds were frozen over to a depth of 10 inches and a great wind piled fifty-foot mountains of ice against its bridges and carried away sections of them."

The Great Atlantic Hurricane of 1944

Manteo was flooded, and many trees were down at Fort Raleigh and the Lost Colony Theater.

Following the storm, one of the most pressing items of need along the Outer Banks was fresh drinking water. Most residents along these sandy islands collected their drinking water in large cisterns. Most of the water supply in these cisterns was contaminated by brackish water due to the flooding. Upon learning of the shortage, the American Red Cross snapped into action, bringing in two portable distillation units that were each capable of making ten thousand gallons of fresh water. In addition, thousands of gallons of fresh water and other emergency supplies were dispatched to Hatteras and Ocracoke aboard the Coast Guard cutter *Pamlico*.

According to the American Red Cross, the official death toll from this killer storm was 390 people. This includes 4 in Connecticut, 26 in Massachusetts, 9 in New Jersey, 6 in New York and 1 in North Carolina. The navy claimed that, in addition to those mentioned earlier aboard the *Warrington*, *Bedloe* and *Jackson*, 344 military personnel died during the storm, including men from a minesweeper *YMS-409* and the Vineyard Sound lightship anchored off Martha's Vineyard. The only person on shore in North Carolina to be killed by the storm was L.S. Parkerson. He was the owner of the Parkerson Hotel at Nags Head and was electrocuted by some power lines that had fallen across his automobile.

THE GREAT HURRICANES OF NORTH CAROLINA

In an area renowned for its bad weather, strong winds and frequent storms, the Great Atlantic Hurricane of 1944 was not soon forgotten by those who lived through it, even if outsiders quickly forgot about it as the news of the day focused on events overseas in the closing days of World War II. This hurricane has the distinction of being the most powerful and destructive hurricane to impact the Outer Banks during the twentieth century.

Hurricane Hazel

Without question, the most famous hurricane to strike the North Carolina coast was Hurricane Hazel. Though each generation has its "great storm," Hazel has maintained its place in the history and lore of the Carolinas throughout the second half of the twentieth century. Thanks to its high winds, destructive storm surge and heavy rains, this powerful and destructive storm remains the hurricane against which all subsequent tempests have been measured.

Hazel earned its reputation honestly. A Category Four hurricane, it came ashore on October 15, 1954, near Little River Inlet on the North Carolina/South Carolina border with wind speeds estimated as high as 150 miles per hour. Hurricane-force winds were experienced along the Carolina coast from Charleston to Cape Hatteras, and as far inland as Ontario, Canada.

This hurricane was a Cape Verde–type storm that developed in the eastern Atlantic. It passed over the southern

The Great Hurricanes of North Carolina

Hurricane Hazel washed out roadways, undermined railroad beds and dashed small boats about like toys as it came ashore in southeastern North Carolina. *Photo courtesy North Carolina Division of Archives and History.*

This aerial view of Swansboro shows the damage inflicted on this Onslow County town by Hurricane Hazel. *Photo courtesy North Carolina Division of Archives and History.*

HURRICANE HAZEL

Right: The yacht club at Wrightsville Beach was severely damaged by Hurricane Hazel. *Photo courtesy North Carolina Division of Archives and History.*

Below: Damage to Carolina Beach was still extensive a month after Hurricane Hazel passed by, as this photo taken on November 15, 1954, demonstrates. *Photo courtesy North Carolina Division of Archives and History.*

The Great Hurricanes of North Carolina

This shrimp boat was driven ashore at Southport by the fierce winds and storm surge of Hurricane Hazel. *Photo courtesy Wilmington District, U.S. Army Corps of Engineers.*

The storm surge from Hurricane Hazel washed many structures from the Brunswick County beaches and deposited them on the mainland. *Photo courtesy Wilmington District, U.S. Army Corps of Engineers.*

Hurricane Hazel left many coastal communities across southeastern North Carolina isolated. *Photo courtesy Wilmington District, U.S. Army Corps of Engineers.*

HURRICANE HAZEL

Boats were left well inland in Southport by Hurricane Hazel's storm surge. *Photo courtesy Wilmington District, U.S. Army Corps of Engineers.*

Boats and docks were damaged by the high winds of Hurricane Hazel along the Intracoastal Waterway near Wrightsville in New Hanover County. *Photo courtesy Wilmington District, U.S. Army Corps of Engineers.*

Hazel inflicted much damage to the waterfront at Southport. *Courtesy North Carolina Division of Archives and History.*

The Great Hurricanes of North Carolina

Hurricane Hazel progressed north into Canada, where it was responsible for widespread destruction in the vicinity of Toronto. More people in Canada were killed as a result of Hurricane Hazel than were killed in North and South Carolina combined. *Photo courtesy Environment Canada.*

Windward Islands on October 6, bringing 100-mile-per-hour winds to Grenada before crossing into the Caribbean Sea. The storm's slow, steady progress to the west seemed to indicate a course that would carry it into Central America, but an abrupt turn to the northeast on October 10 carried Hazel into western Haiti on October 12, where 125-mile-per-hour winds and heavy rains inflicted much damage and killed an estimated thousand people.

As the storm cleared Haiti it was considerably weakened. When it passed through the southern Bahamas, winds had diminished to only forty miles per hour. However, the storm began to change its course toward the northwest and strengthened rapidly. By the evening of October 14, Hazel was headed straight for Savannah, Georgia, but another change in course toward the north brought the fierce storm ashore on the coast north of Myrtle Beach.

HURRICANE HAZEL

This National Weather Service chart shows the path of Hurricane Hazel as it traveled across the Caribbean, through the United States and into Canada.

Hurricane Hunter aircraft from both the navy and the air force kept a close watch on Hazel. As the storm moved out of the Bahamas on October 14, meteorologist Captain William Harrell was on board for one of the air force flights into the rapidly intensifying storm, and he noted that the eye of the hurricane was only about eight miles in diameter. He also reported that the turbulent waters on the surface of the sea appeared white in color instead of the normal green.

Another person flying missions into Hurricane Hazel was Lieutenant Maxey Watson, a naval pilot who on several occasions flew into this storm. He followed the storm north from the Caribbean, all the way to the North Carolina coast. His last flight into Hazel brought him into the eye of the storm just off the coast of Myrtle Beach, which was near his hometown of Conway, South Carolina.

THE GREAT HURRICANES OF NORTH CAROLINA

One person who was keeping track of the progress of the storm was Grady Norton of the U.S. Weather Bureau's Miami office. He was the nation's foremost expert at hurricane forecasting, and had been responsible for overseeing many advances in the techniques used to forecast hurricanes, playing a key role in the early history of aircraft being utilized to track and study hurricanes. Tragically, he had put in a long day on October 9, 1954, trying to figure where exactly Hurricane Hazel was headed, and as a result he had a stroke and died.

Damage to the South Carolina coast was extensive, especially in the area from Pawley's Island north. Weather Bureau reports noted:

> *Most damage along the ocean front as in North Carolina was caused by water which came in on 20 foot waves on a high tide of 10 or 11 feet. Hundreds of buildings were destroyed and even building lots eliminated by the waves.*

At Garden City, a young community that was just starting to grow, Hazel brought howling winds and a storm surge that inundated the town. When the waters receded, it was found that 273 of the town's 275 residences were damaged to the point of no longer being habitable, while the entire downtown business section was destroyed.

At Myrtle Beach, damage was extensive, but since the famous beach resort was on the relatively weak left front

quadrant of the storm, the city was spared a catastrophic blow. Still, there was much damage along the Grand Strand, where hotels and beachfront cottages were torn to shreds. In some areas, entire sections of sand dunes were washed into the sea. The eye of the storm slipped just east of Myrtle Beach shortly after 9:00 a.m. A minimum barometric pressure of 28.47 inches was recorded at the airport at 9:25 a.m., with maximum sustained winds of 106 miles per hour.

At 10:30 a.m., the eye of Hurricane Hazel made landfall in the vicinity of Little River Inlet, on the border of North and South Carolina. Captain Leroy Kinlaw rode out the storm aboard his fishing boat, the *Judy Ninda*, which was anchored at Tilghman Point. His barometer, later verified to be accurate by the Weather Service office in Wilmington, registered a low pressure of 27.70 inches. According to hurricane researchers Gordon Dunn and Banner Miller, Little River Inlet is the place where the center of this powerful hurricane came ashore.

> *The estimated time of the relative calm was thirty minutes, which was the longest reported anywhere, and it is thought the geometric center of the hurricane passed over this point. The barometer was checked by the Wilmington Weather Bureau office and found to be accurate. According to Captain Kinlaw, the highest wind and water came just after the eye passed, and the highest tide was estimated at 14.5 feet.*

At Calabash, a small North Carolina fishing village made famous for its distinctive style of seafood, the eye of the hurricane passed at approximately 11:00 a.m. Reuben Frost, Weather Bureau chief for the National Weather Service at Wilmington, later spoke with many of the locals to get their accounts of the conditions during the storm. He concluded that the center of the storm took up to thirty minutes to clear the area.

The powerful, right front quadrant of Hazel came ashore along the south-facing Brunswick County beaches, bringing massive and catastrophic destruction to Holden Beach, Long Beach and Ocean Isle. In addition to ferocious 150-mile-per-hour winds, Hazel brought an eighteen-foot storm surge onto these low-lying sandy barrier islands that were completely inundated by the rising tide. Wilmington Weather Bureau Chief Frost personally inspected the damage to these beaches shortly after the storm had passed. He described the scene as follows:

> *Winds were estimated at 150 miles per hour and the storm tide reached 18 feet on the Brunswick County coast. There was great destruction. The beach settlements on Ocean Isle, Holden Beach and Long Beach were destroyed. There was five feet of water over Wrightsville Beach where 89 houses were destroyed and 530 damaged…At Carolina Beach 475 houses were destroyed and 1,365 damaged.*

The official report from the Weather Bureau office in Raleigh elaborated on Frost's description:

All traces of civilization on that portion of the immediate waterfront between the state line and Cape Fear were practically annihilated. Grass-covered dunes some 10 to 20 feet high along and behind which beach homes had been built in a continuous line five miles long simply disappeared, dunes, houses and all. The paved roadway along which the houses were built was partially washed away, partially buried beneath several feet of sand. The greater part of the material from which the houses had been built was washed from one to two hundred yards back into the edge of the low-lying woods which cover the leeward side of the islands. Some of the material is identifiable as having been parts of houses, but the greater portion of it is ground to unrecognizable splinters and bits of masonry. Of the 357 buildings which existed on Long Beach, 352 were totally destroyed and the other five damaged. Similar conditions prevail on Holden Beach, Ocean Isle, Robinson Beach and Colonial Beach.

Captain Julian Fulford rode out the storm aboard his boat, the *Nina Fay*, anchored in the Intracoastal Waterway near the bridge at Holden Beach. He reported that the eye of the storm passed his location at approximately 11:00 a.m., and lasted for less than thirty minutes. His onboard barometer measured a lowest pressure of 27.90 inches. The captain, whose vessel was the only one of the local shrimp boats to remain afloat during Hurricane Hazel, estimated that the

wind was howling at 150 miles per hour during the height of the storm at Holden Beach.

After crossing the shoreline at approximately 10:30 a.m., Hazel dashed across North Carolina at forward speeds of over fifty miles per hour. Along the way, buildings and crops were heavily damaged, and power lines were downed. As the storm sped north across the state, it brought torrential rains and hurricane-force winds to the eastern section of North Carolina. From Brunswick County, the center of the mighty storm passed near Clinton, Goldsboro, Rocky Mount and Wilson. Reports of wind gusts in excess of a hundred miles per hour were recorded from several towns east of Raleigh. At the Raleigh-Durham Airport, maximum sustained winds were seventy-three miles per hour, with gusts up to ninety miles per hour.

These fierce winds caused a variety of damage across the state. Thousands of trees were either blown over or snapped off by the strong winds causing much damage to forests. In towns there was much damage from fallen trees, which crushed cars, smashed roofs and downed power lines. Electricity was out in many places, including Raleigh. Telephone services were out in many areas, including Wilmington.

The heaviest rainfall in the interior portions of the state fell on Moore County, where Carthage picked up 9.72 inches and Robbins received 11.25 inches. This rain was especially welcome as the state was suffering from a severe drought, which was being felt all across the southeastern United States at the time.

Hurricane Hazel

By 2:30 p.m. Hurricane Hazel passed out of North Carolina and into Virginia. The storm was little diminished as it raced north, spreading destruction across a wide swath of the Old Dominion. Thousands were left without power as trees blown down by the fierce winds knocked out power lines in cities such as Fredericksburg and Richmond. There was extensive damage in Chesapeake Bay, including the destruction of most of the state's crab pots.

That afternoon, the swift-moving Hazel cleared Virginia and moved quickly across Maryland, Pennsylvania and New York. Remarkably, by 9:00 p.m. on October 15, 1954, the hurricane that had made landfall on the Carolina coast less than twelve hours earlier was in Canada. The storm crossed Lake Ontario, bringing death and destruction to the people of Toronto. The storm had lost most of its ferocious winds, but the rains were unprecedented and unexpected. The deluge that fell from Hazel over Ontario was responsible for more deaths in Canada than the hurricane had inflicted on North Carolina and South Carolina combined.

What caused the torrential rains from Hazel in Canada? To understand, one has to look beyond tropical meteorology, as the storm was interacting with weather features that originated in colder regions. A cold front moving down from the north was over Ontario and had dropped several inches of rain over the area earlier that day. As Hazel sped north, it got caught up in this cold front, and the warm tropical air rose above the cooler air at the surface. The rising effect of the air helped draw

moisture out of the already moist, tropical air associated with the cyclone. The result was a deluge of epic proportions for the people who lived in Toronto and the surrounding areas.

"Hurricane Hazel induced the most severe flooding in Toronto in over 200 years," wrote Jeanne Andrews of Environment Canada. "As much as the floodplain had been developed, the flood damage was high, being estimated at over $25 million ($133.3 million in 1991 dollars). Over 20 bridges were destroyed or damaged beyond repair, 81 lives lost, and 1868 families left homeless."

Although the storm lost its tropical characteristics shortly after passing into Canada, Hazel's northern excursion was far from over. L.H. Seamon of the U.S. Weather Bureau reported:

> *After passing into Canada where heavy rains and floods resulted in about 100 deaths and $100,000,000 damage, the storm was traced northward to near the southeastern shore of Hudson Bay, from whence it swung eastward, crossed the southern tip of Greenland on the 19th and was last reported somewhere north of Sweden on the 21st.*

Hazel was truly the most powerful and remarkable storm to strike North Carolina during the twentieth century, and it was one of the most intriguing storms ever witnessed in the North Atlantic. The death and destruction left in this killer hurricane's wake gives Hurricane Hazel the distinction of being our state's most memorable hurricane.

Hurricanes of the Late Twentieth Century

Since the passage of Hurricane Hazel in the fall of 1954, no other storms that can be categorized as "great" have struck the North Carolina coast. Some, such as Fran and Floyd, came close to claiming that distinction, while others such as Donna and Hugo made landfall somewhere else and spent their fury over other regions before visiting our state. There were some memorable storms with high winds and heavy rains, but for more than half a century, the really powerful storms went elsewhere.

Not that there were not some memorable storms. As a matter of fact, the 1955 season was one of the most interesting seasons along the North Carolina coast during the twentieth century. Three hurricanes made landfall that season. Hurricane Connie was a slow-moving storm that made landfall on August 18 near Cape Lookout. Five days later, Hurricane Diane made landfall near Carolina Beach. Because these storms landed within such proximity to each

The Great Hurricanes of North Carolina

HURRICANES OF THE LATE TWENTIETH CENTURY

Hurricane Isabelle struck the Outer Banks on September 18, 2003. Though only a Category Two hurricane on the Saffir-Simpson Scale, the storm surge was still powerful enough to breach the sandy barrier island, creating this inlet that severed the western end of Hatteras Island from the rest of the Outer Banks. *Photo courtesy U.S. Geological Survey*.

Opposite above: Hurricane Floyd made landfall on the coast of North Carolina on September 16, 1999. *Photo courtesy National Oceanic and Atmospheric Administration*.

Opposite below: This satellite image shows Hurricane Fran as it made landfall on the North Carolina coast on September 5, 1996. *Photo courtesy National Oceanic and Atmospheric Administration.*

Hurricane Donna caused much destruction along the North Carolina coast, including this damage to Atlantic Beach in Carteret County. Though it was one of the most powerful and destructive storms of the twentieth century, North Carolinians were fortunate to escape the worst effects of this killer storm, which brought wind gusts up to two hundred miles per hour to the Florida Keys before moving north along the Atlantic seaboard and into New England. *Photo courtesy North Carolina Division of Archives and History*.

other time wise, officials were unable to calculate the total amount of damage from the respective storms, but it was well over $100 million. Then came Hurricane Ione, which made landfall along the Bogue Banks in Carteret County on September 19, 1955. None of these storms packed winds that were particularly noteworthy, but they all brought heavy rains that drenched eastern North Carolina.

These three hurricanes of 1955 were responsible for some notable flooding in the eastern portion of the state. Since the approach of Hurricane Connie on August 10, North Carolina had been repeatedly drenched with heavy rains. "More than 30 inches fell on the wettest portions of the state between the 10th and the approach of Ione," wrote James Hudgins, a meteorologist with the National Weather Service who spent much time researching North Carolina's hurricane climatology while stationed at the National Weather Service Office at Newport.

> *The additional 16 inches that fell on those same areas in connection with Ione brought 45-day rainfall totals up to figures without precedent in North Carolina weather history. In the 41-day period, August 11th through September 20th, the cooperative weather substation at Hofmann Forest (6 miles southwest of Maysville) received a total of 48.90 inches of rain.*

Another notable hurricane that struck the coast of North Carolina during this period was Hurricane Donna on September 11, 1960. One of the most potent hurricanes to ever strike the United States, Donna was a very destructive storm packing 120-mile-per-hour winds when it came ashore in the Florida Keys. This was a resilient storm that maintained its hurricane-force winds as it proceeded up the Atlantic Coast, slamming ashore in Onslow County on

the North Carolina coast before reemerging back over the ocean and coming ashore in New England. The maximum sustained winds from this storm were nearly 100 miles per hour when it passed over North Carolina, where it inflicted $56 million in damage.

During this lull in hurricane activity along the coast of North Carolina, the interior portions of the state felt the effects of a great hurricane that made landfall in South Carolina. Hurricane Hugo, a massive Category Four hurricane, came ashore at Isle of Palms, near Charleston, South Carolina, on September 22, 1989. A Cape Verde hurricane, Hugo emerged as a tropical wave from the coast of Africa on September 9, and quickly grew into a hurricane by September 13, 1989. Hugo reached its peak intensity as a Category Five storm on September 15, but weakened slightly before plowing into the Leeward Islands on the eighteenth. The storm took a turn to the northwest and cut across the eastern portion of Puerto Rico before heading in a weakened condition through the Bahamas for the South Carolina coast.

Gaining strength as it crossed the Gulf Stream, the hurricane made landfall a short distance to the north of Charleston on September 22. Strengthening in the last twelve hours before landfall made Hugo a Category Four hurricane when it reached the coast, packing over 130-mile-per-hour winds. Hugo's storm surge swamped much of the South Carolina coast between Charleston and Myrtle Beach.

Storm tides of twenty feet were observed in the vicinity of Cape Romain and Bulls Bay.

A ship moored in the Sampit River near Georgetown, South Carolina, recorded sustained winds of 120 miles per hour. The high winds from Hugo were felt in the interior regions of the Carolinas. Shaw Air Force Base, near Sumter, South Carolina, reported sustained winds of 67 miles per hour, with gusts as high as 110 miles per hour. At Columbia, winds gusted to nearly 100 miles per hour. In Charlotte, North Carolina, sustained winds of 69 miles per hour and gusts near 100 miles per hour downed trees and power lines, cutting off electricity to some customers in the area for three weeks.

During the mid-1990s, it seemed as though weather patterns had returned to normal as fierce hurricanes took aim at the Carolina coast. Between 1996 and 1999, five hurricanes struck the North Carolina coast. This was an outbreak of hurricanes that coastal residents had not seen since the 1954–55 seasons when five storms battered the coast from Myrtle Beach to Corolla.

The intervening lull in hurricane activity from the 1950s through the 1990s witnessed unprecedented growth in population for North Carolina, especially the coastal regions. Few of our nineteenth-century forebears would have been able to foresee the rampant population explosion that has turned what was once one of the most remote stretches of the Atlantic seaboard of the United

States into a place where millions of people live and vacation. Many of the late twentieth-century inhabitants of the coast, both natives and newcomers alike, were inexperienced and ill-equipped to deal with the ravages of these tropical cyclones. It is no wonder that the destruction unleashed would be the most costly natural disasters in the state's history.

The hurricane that began this streak was Bertha, a Category Two storm packing winds of ninety miles per hour. It came ashore near Cape Fear on July 12, 1996, and headed north to Virginia. This storm is credited with causing $135 million in damage, and it claimed two lives.

Packing 115-mile-per-hour winds, Fran made landfall near the mouth of the Cape Fear River on September 5, 1996, and caused much destruction along the coast between Southport and Swansboro. Particularly hard hit was Topsail Island in Onslow County. Fran unleashed high winds and heavy rains into the interior of the state, causing massive power outages in areas such as Raleigh, Durham and Chapel Hill, places not usually associated with hurricane damage. Damage costs were $6 billion from Fran, a storm that was responsible for twelve deaths.

The next hurricane to strike the coast was Bonnie, which made landfall near the mouth of the Cape Fear River on August 26, 1998. This was a Category Two storm, packing winds of 110 miles per hour when it came ashore. Bonnie caused more than $1 billion in damage in

North Carolina, mainly in the counties of New Hanover, Pender and Onslow.

The 1999 hurricane season witnessed two hurricanes making landfall in North Carolina. Hurricane Dennis set an erratic course that first skirted just offshore along the coast, but before it could clear the area, it made a loop in the Atlantic and headed west, making landfall near Cape Lookout on September 4, 1999, with winds that had decreased to tropical storm force. The rain, winds and waves generated by this storm as it sat off the Outer Banks and pounded the coast for more than a week caused $157 million in damage to Virginia and North Carolina.

The last of these storms was Floyd, which made landfall near the mouth of the Cape Fear River on September 15, 1999. Though maximum sustained winds for the storm had been near 155 miles per hour with gusts up to 185 miles per hour, the hurricane fortunately weakened somewhat before making landfall with winds of 105 miles per hour. The heavy rainfall that fell upon ground already saturated by Dennis's visit earlier in the month led to catastrophic flooding across eastern North Carolina.

During its eventful existence, Floyd was responsible for many records. This hurricane caused the largest peacetime evacuation in United States' history as over three million residents from Florida to North Carolina were instructed by emergency management officials to seek higher ground. Floyd was also the costliest

natural disaster in North Carolina history, inflicting damage estimated between $3 and $6 billion. The storm claimed fifty-seven lives, making it the most deadly hurricane to strike the East Coast since Hurricane Agnes in 1972.

Though costly in a monetary sense, these hurricanes of the 1990s were not in the same league with earlier storms that plagued our shores. These were all destructive storms in their own rights, but none were as intense or powerful as the killer storms that plagued the North Carolina coast in days gone by. It is only a matter of time before another catastrophic storm of such dimensions as Hurricane Hazel or the Great Atlantic Hurricane makes landfall along the North Carolina coast. One can only imagine the cost and destruction that will be meted out the next time a storm of the intensity of the Great Beaufort Hurricane or the San Ciriaco Hurricane visits the Carolina coast.

Appendix

THE SAFFIR-SIMPSON HURRICANE SCALE

Category	Definition/Effects
One	**Winds: 74–95 miles per hour** (64–82 knots) Barometric pressure greater than 980 millibars, or 28.94 inches. Storm surge: Less than 5 feet. No real damage to building structures. Damage primarily to unanchored mobile homes, shrubbery and trees. Also, some coastal flooding and minor pier damage. Examples: Irene 1999 and Allison 1995

APPENDIX

Category	Definition/Effects
Two	**Winds : 96–110 miles per hour** (83–95 knots) Barometric pressure 979–965 millibars, or 28.50–28.91 inches. Storm surge: 6–8 feet. Some roofing material, door and window damage. Considerable damage to vegetation, mobile homes, etc. Flooding damages to piers, and small craft in unprotected moorings may break their moorings. Examples: Bertha 1996, Bonnie 1998, Floyd 1999 and Isabel 2003
Three	**Winds : 111–130 miles per hour** (96–113 knots) Barometric Pressure 964–945 millibars, or 27.91–28.47 inches. Storm surge: 9–12 feet. Some structural damage to small residences and utility buildings, with a minor amount of curtain wall failures. Mobile homes are destroyed. Flooding near the coast destroys smaller structures with larger structures damaged by floating debris. Terrain may be flooded well inland. Examples: Fran 1996

The Saffir-Simpson Hurricane Scale

Category	Definition/Effects
Four	**Winds : 131–155 miles per hour** (114–135 knots) Barometric Pressure 944–920 millibars, or 27.17–27.88 inches. Storm surge: 13–18 feet. More extensive curtain wall failures with some complete roof structure failure on small residences. Major erosion of beach areas. Terrain may be flooded well inland. Examples: Hazel 1954 and Hugo 1989
Five	**Winds : 155+ miles per hour** (135+ knots) Barometric Pressure less than 920 millibars, or 27.17 inches. Storm surge: Greater than 18 feet. Complete roof failure on many residences and industrial buildings. Some complete building failures with small utility buildings blown over or away. Flooding causes major damage to lower floors of all structures near the shoreline. Massive evacuation of residential areas may be required. Examples: Andrew 1992, Camille 1969 and Labor Day 1935

BIBLIOGRAPHY

Andrews, Jeanne, ed. *Flooding Canada Water Book*. Ottawa, Canada: Minister of the Environment, Ecosystem Science and Evaluation Directorate, 1993.

Barnes, Jay. *North Carolina's Hurricane History*. Chapel Hill: University of North Carolina Press, 1995.

Brindze, Ruth. *Hurricanes: Monster Storms from the Sea*. New York: Atheneum, 1973.

Chenery, Richard L. *Old Coast Guard Stations Volume Two North Carolina*. Glen Allen, VA: Station Books, 2000.

Cline, I.M. *Tropical Cyclones*. New York: MacMillan Company, 1926.

Cloud, Ellen Fulcher. *Portsmouth The Way it Was*. Ocracoke, NC: Live Oak Publications, 1996.

BIBLIOGRAPHY

Danielson, E.W., J. Levin and E. Abrams. *Meteorology*. New York: McGraw-Hill Company, 1998.

Davis, Walter R. "Hurricanes of 1954." *Monthly Weather Review* (December 1954): 370–373.

Fassig, O.L. *Hurricanes of the West Indies*. Bulletin No. 13. Washington, D.C.: U.S. Weather Bureau, 1913.

Foley, G.R., H.E. Willoughby, J.L. McBride, R.L. Elsberry, I. Ginnis and L. Chen. *Global Perspectives on Tropical Cyclones*. Report Number TCP-38. Geneva: World Meteorological Organization, n.d.

Frost, Reuben L. "Record of Cape Fear Hurricanes." Unpublished manuscript, 1957.

Herndon, G. Melvin. "The 1806 Survey of the North Carolina Coast, Cape Hatteras to Cape Fear." *North Carolina Historical Review* XLIX, 3 (July 1972): 242–253.

Hudgins, James F. *Tropical Cyclones Affecting North Carolina Since 1586—An Historical Perspective*. National Oceanic and Atmospheric Administration Technical Memorandum NWS ER-92. National Weather Service, April 2000.

Jackson, Claude V., III. *The Cape Fear–Northeast Cape Fear Rivers Comprehensive Study, A Maritime History and Survey of the Cape Fear and Northeast Cape Fear Rivers, and Wilmington Harbor,*

North Carolina. Vol. 1. Kure Beach, NC: Underwater Archeology Unit, April 1996.

Krueger, A.F. "The Weather and Circulation of October 1954—Including a Discussion of Hurricane Hazel in Relation to the Large-scale Circulation." *Monthly Weather Review* (October 1954): 296–300.

Ludlum, David. *Early American Hurricanes 1492–1870*. Boston, MA: American Meteorological Society, 1963.

Merrill, Buddy. "The Storm of '44 One of the Worst to Hit Hatteras Island." *Sea Chest* 5, 1 (Fall 1978): 16–17.

Messinger, William Elliott, and Charles Talcott Orloff. *The Great Atlantic Hurricane September 8–16, 1944, An Historical & Pictorial Summary*. East Milton, MA: Blue Hill Meteorological Observatory, 1994.

Mobley, Joe A. *Ship Ashore! The U.S. Lifesavers of Coastal North Carolina*. Raleigh, NC: Division of Archives and History, 1994.

Neuman, Charles J., and Brian R. Jarumman. *Tropical Cyclones of the North Atlantic Ocean, 1871–1992*. Asheville, NC: National Climatic Data Center, November 1993.

Newton, Art, ed. *Hurricane Hazel Lashes the North Carolina Coast*. Wilmington, NC: Wilmington Printing Company, 1954.

BIBLIOGRAPHY

O'Neal, Calvin J., Alice K. Rondthaler and Anita Fletcher. *The Story of Ocracoke*. Hyde County Historical Society, 1976.

Pielke, Roger A. *Hurricanes: Their Nature and Impacts on Society*. Chichester, NY: Wiley, 1997.

Powell, William S. *The North Carolina Gazetteer*. Chapel Hill: University of North Carolina Press, 1968.

Reid, William C. *An Attempt to Develop the Law of Storms*. London: John Weale, 1850.

———. *The Progress of the Development of the Law of Storms, and of Variable Winds, with the Practical Application of the Subject to Navigation*. London: J. Weale, 1841.

Riehl, Herbert. *Tropical Meteorology*. New York: McGraw-Hill Book Company, 1954.

Saunders, William L., ed. *The Colonial Records of North Carolina*. 10 vols. Raleigh: State of North Carolina, 1886–1890.

Schwartz, Stuart B. "The Hurricane of San Ciriaco: Disaster, Politics, and Society in Puerto Rico, 1899–1901." *Hispanic American Historical Review* 72, 3 (August 1992): 303–330.

Seamon, L.H. "The Storm of October 15, 1954." *Climatological Data—National Summary* 5, 1 (October 1954): 381–385.

Sprunt, James. *Chronicles of the Cape Fear River 1660–1916.* Raleigh, NC: Edwards & Broughton Printing Company, 1916.

Stevens, A.E., and M. Stavely. "The Great Newfoundland Storm of 12 September 1775." *Bulletin of the Seismological Society of America* 81, 4: 1398–1402.

Stevens, Anne. "Reply to Comments on 'The Great Newfoundland Storm of 12 September 1775' by A.E. Stevens and M. Stavely." *Bulletin of the Seismological Society of America* 85, 2: 650–652.

Stevenson, J.D. *A Historical Account of Tropical Cyclones That Have Impacted North Carolina Since 1589.* NOAA Technical Memorandum NWS ER-83. National Oceanic and Atmospheric Administration, 1990.

Stick, David. *Graveyard of the Atlantic: Shipwrecks of the North Carolina Coast.* Chapel Hill: University of North Carolina Press, 1952.

———. *North Carolina Lighthouses.* Raleigh: North Carolina Department of Cultural Resources, Division of Archives and History, 1980..

———. *The Outer Banks of North Carolina, 1584–1958.* Chapel Hill: University of North Carolina Press, 1958.

Bibliography

Sumner, H.C. "The North Atlantic Hurricane of September 8–16, 1944." *Monthly Weather Review* (September 1944): 187–189.

Tannehill, Ivan Ray. *The Hurricane Hunters*. New York: Dodd, Mead, 1955.

———. *Hurricanes: Their Nature and History; Particularly those of the West Indies and the Southern Coasts of the United States*. 8th ed. Princeton, NJ: Princeton University Press, 1952.

Thompson, Redding G. "The August Storm of 1899." *The State* (August 1978): 22–23.

Williamson, Sonny. *Shipwrecks of Ocracoke Island*. Marshallberg, NC: Grandma Publications, 2000.

———. *Unsung Heroes of the Surf: The Lifesaving Service of Carteret County*. Marshallberg, NC: Grandma Publications, 1992.

Newspapers

Carolina Observer
Carteret County News Times
Charlotte Observer
Daily Advance
Edenton Gazette
Edinburgh Evening Courant
Elizabeth City Star & North Carolina Eastern Intelligencer

BIBLIOGRAPHY

Farmer & Mechanic
Fayetteville Observer
The Minerva
Newbernian
News & Observer
New York Times
North Carolinian
People's Press
Pinckney's Virginia Gazette
Raleigh Observer
South Carolina & American General Gazette
State Port Pilot
Virginia Gazette
Virginian Pilot
Wilmington Advertiser
Wilmington Daily Herald
Wilmington Gazette
Wilmington Journal
Wilmington Morning Star

Visit us at
www.historypress.net